FairyArt

painting
magical fairies
and their worlds

David Adams

IMPACT
CINCINNATI, OHIO
www.impact-books.com

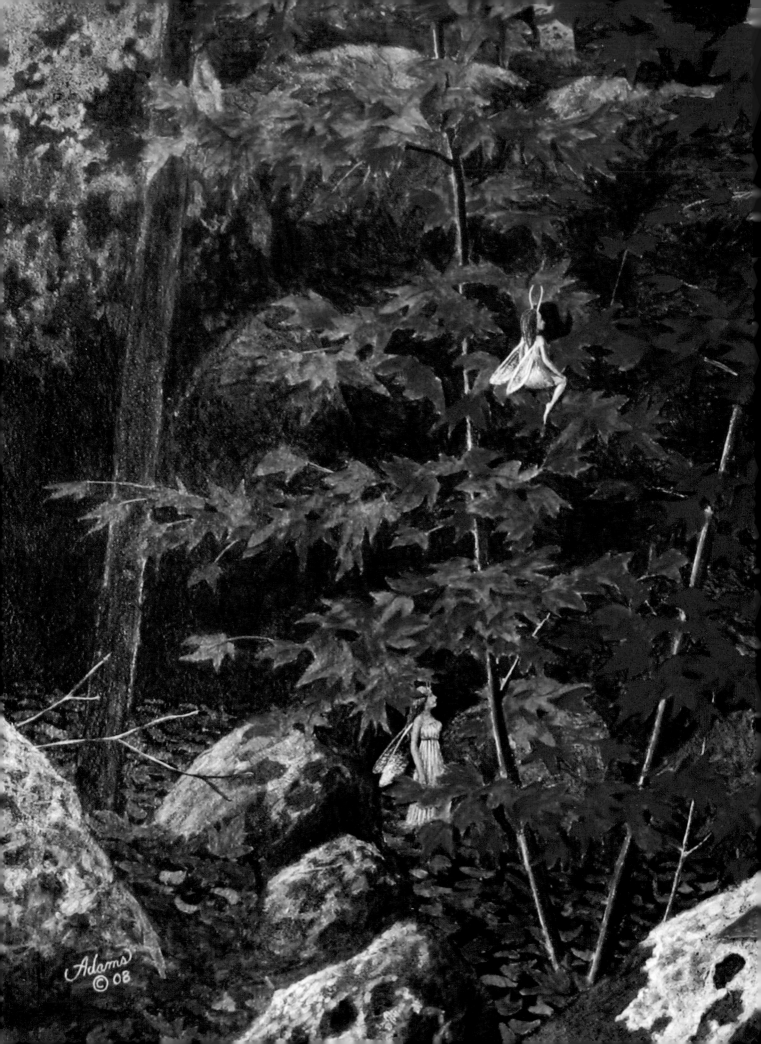

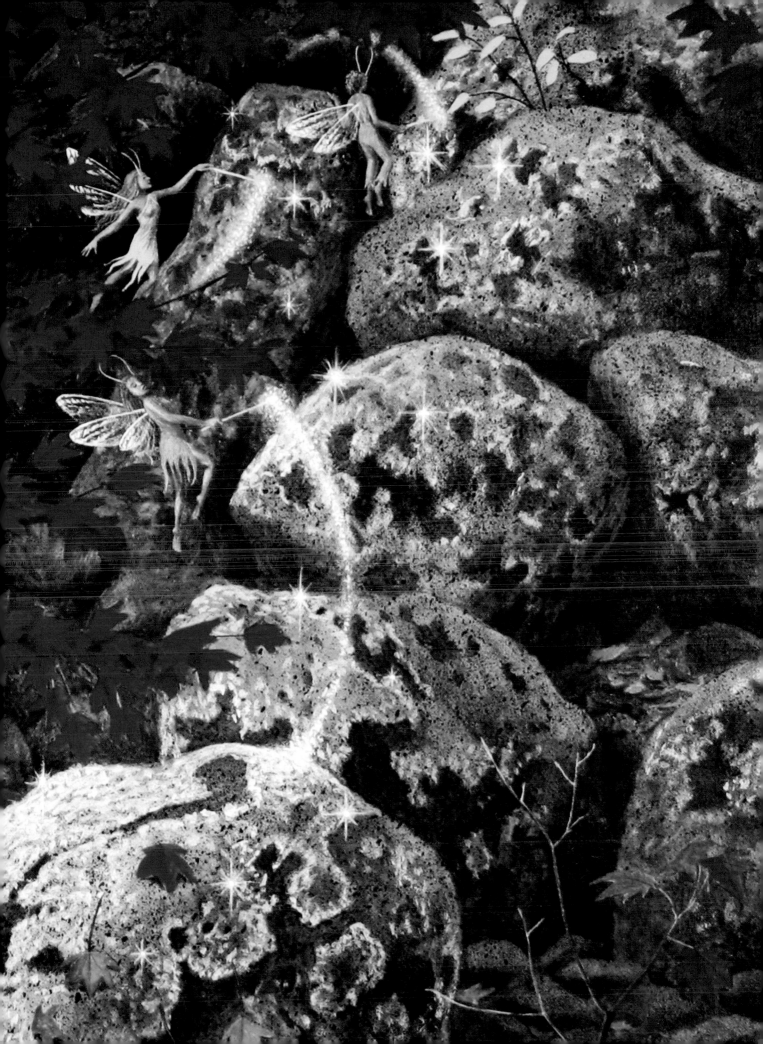

About the Author

David Adams is a self-taught professional artist and online teacher. He has perfected his skills over many years of practice, reading, observing and sharing with fellow artists.

Born in Japan, David now resides in Washington state. His inspiration is derived from nature; years of observing and photographing the natural beauty of Mother Earth has provided a wealth of reference material for his paintings.

Following high school, David taught painting for the summer interim at Perry Keithley Junior High in Tacoma, Washington. Although he was asked to continue teaching, he decided to focus on his painting.

David has won many awards for his paintings. His first gallery representation was with the Signature Gallery in Tacoma. Some of his works have been cover art and illustrations for books and magazines. He has also judged several local art exhibitions.

David is also one of the top scrimshaw artists in the U.S.; his work is displayed in private and public collections worldwide. He also designs jewelry and carves crystals, using the "reverse intaglio" technique.

David's art is in demand worldwide, keeping him constantly busy with a long waiting list of clients. He freely passes on his knowledge and techniques to the art community through his website www.davidadamsonline.com and his newsletter. David's website is a recipient of numerous awards for art and web design.

Other fine IMPACT Books are available from your local bookstore or art supply store. Also visit our website at www.fwmedia.com.

13 12 11 10 09 5 4 3 2 1

DISTRIBUTED IN CANADA BY FRASER DIRECT
100 Armstrong Avenue
Georgetown, ON, Canada L7G 5S4
Tel: (905) 877-4411

DISTRIBUTED IN THE U.K. AND EUROPE BY DAVID & CHARLES
Brunel House, Newton Abbot, Devon, TQ12 4PU, England
Tel: (+44) 1626 323200, Fax: (+44) 1626 323319
Email: postmaster@davidandcharles.co.uk

DISTRIBUTED IN AUSTRALIA BY CAPRICORN LINK
P.O. Box 704, S. Windsor NSW, 2756 Australia
Tel: (02) 4577-3555

Library of Congress Cataloging in Publication Data
Adams, David,
 FairyArt : painting magical fairies and their worlds / by David Adams. -- 1st ed.
 p. cm.
 Includes index.
 ISBN 978-1-60061-089-9 (pbk. : alk. paper)
 1. Fairies in art. 2. Painting--Technique. 3. Drawing--Technique. I. Title. II. Title: Fairy art.
 ND1460.F32A33 2009
 753'.7--dc22 2008045999

Edited by Mary Burzlaff Bostic
Designed by Guy Kelly
Production coordinated by Matt Wagner

Metric Conversion Chart

To convert	to	multiply by
Inches	Centimeters	2.54
Centimeters	Inches	0.4
Feet	Centimeters	30.5
Centimeters	Feet	0.03
Yards	Meters	0.9
Meters	Yards	1.1

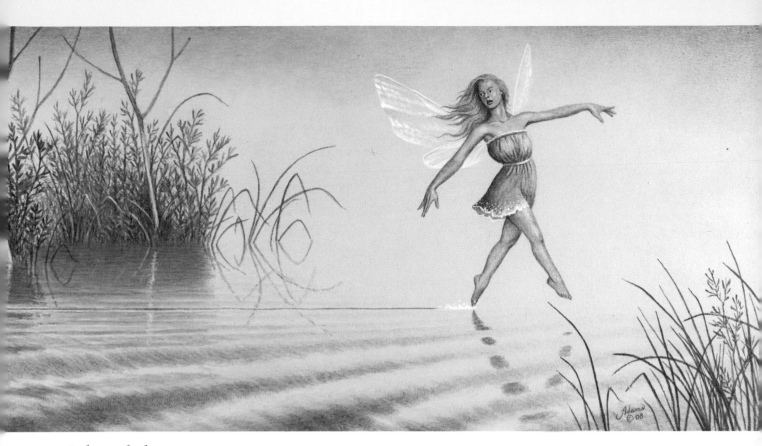

Acknowledgments

I'd like to thank my mother, Chieko Oyama Smith, and my siblings, John, Roy, James, Betty, Lynda and Judy, all of whom have been wonderfully supportive of my art career.

I thank my two close friends, Trisha Joy (a fantastic gemstone carver) and Carter Remington (an award winning poet). Trisha has been a great help with titling my paintings throughout the years.

I give a warm thanks to all of my models: Jennifer B. Matas, Catherine Scott, Jessica B. Smith, Katia M. Smith and Jayden M. Smith.

I'd like to thank my friend and longtime fan, Dr. Glen Apseloff, who provided me with so many fantastic photos to use as reference for my paintings.

I give a special thank you to my dear friend, Ana Lúcia Heringer (Lu), who introduced me to the new concept of color theory and has written the color theory section for this book.

I also thank Mary Bostic, a great editor and a wonderful person to work with. Thanks also to Pamela Wissman, Guy Kelly, Adam Hand and Matt Wagner at IMPACT. Also, thanks to Ric Deliantoni for his invaluable photography instruction and advice. All these people have done a superb job of putting together my words and images to create this beautiful book.

I thank my fans as well! Especially, Bette Haynes. Without my fans, I would be nothing.

Dedication

This book is dedicated to my father, Roy Grover Smith. He was a great man, a loving father, a war hero and a friend to all. May he rest in peace.

Contents

Introduction

Part 1

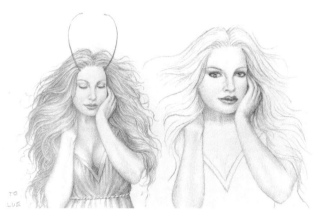

Basic Drawing and Painting Techniques

Paints · Brushes · Painting Supports · Other Painting Supplies · Basic Drawing and Sketching · Working Process · Value · Basic Principles of Color Theory · Color Temperature · Color Saturation · Mixing Colors · Optical Color Mixing · Toned Ground · Underpainting · Glazing · Linear Perspective · Atmospheric Perspective · Overlapping · Composition

Part 2

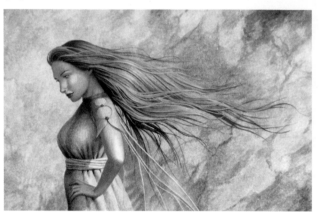

Drawing and Painting Magical Fairies

Fairy Features · Hands and Feet · Drawing the Basic Female Figure · Drawing the Basic Male Figure · Skin Tones · Hair Types · Fairy Wings · Flowing Hair · Fairy Clothing · Basic Flying Pose · Sitting Pose · Flowing Garments · Sparkles, Light and Magical Effects

Demonstrations:

Curious Fairy · Baby Fairy · Warm Color Scheme · Cool Color Scheme

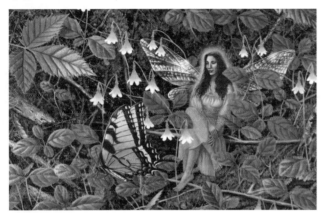
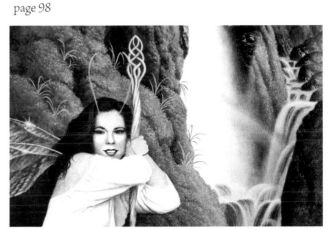

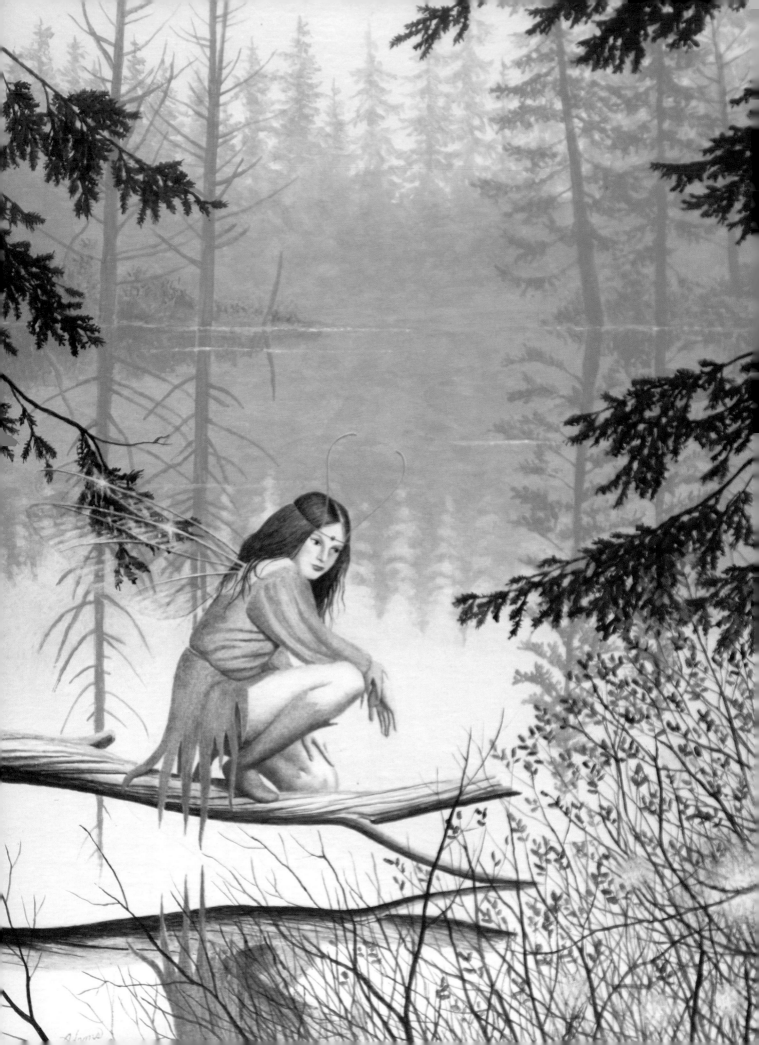

Introduction

The world of fantasy stirs our imaginations with enchantment and delight as we gaze into realms of magic and myth. Throughout the centuries, artists have been inspired to interpret the unknown, capturing ephemeral sprites and radiant fairies.

Fairies are humanlike beings who exist on a dimensional plain parallel to ours. They are lively and sometimes mischievous creatures. Fairies are the true caretakers of nature, responsible for seasonal changes. The fairy realm has a dark side too, but I like to focus on the light. All of my depictions of fairies are positive and show the good side of the fairy world.

I love to paint fairies because I like to believe that there is an unseen realm of wonderful beings who play, dance, sing and rejoice in this beautiful world we call Earth. I've seen a lot of things that I can only describe as magical on my many hikes through nature. To me, there has to be a benevolent, unseen force behind this wonderful beauty.

Magic works best when it is seen as intricate and realistic. In my paintings, I present the fantasy world of the fairy realms within the framework of tangible landscapes. This gives the viewers believable dreamscapes in which to engage their imaginations.

Mother Nature, with her wealth of beauty, provides an abundance of material for the fantasy artist. The natural world inspires art and renders a foundation on which to build the fantastic.

Combining my realistic interpretation of fairies with the recognizable forms of nature imparts a sense of wonderment and magic in the world itself.

This book will give you basic instruction for drawing and painting fairies. Each artist has his own way of painting. My technique is straightforward and easy to understand. In this book, I'll explain in simple terms the procedure I use to create beautiful pictures, and you can develop your own methods.

Painting is a joyful experience. Approach it with a smile and have fun.

1

Basic Drawing and Painting Techniques

Your fairy paintings are limited only by the extent of your imagination and your ability to interpret your concepts with paints. In this book, I will help you hone your skills so that you can successfully capture the fantasy in your mind.

You must understand the fundamentals of painting in order to paint a successful picture. This section covers all the basics: from tools, to basic color theory, to composition. And the most important steps: practice, practice and practice. Your first few attempts may meet with failure, but don't give up. We learn much through trial and error.

Creating fantasy art is a challenge. You are portraying the dreamscapes of your mind. It cannot be photographed, so you must do your best to interpret a plane of existence that cannot be seen in real life. Essentially, you are an illusionist who expresses the worlds that others dream about. To paint fairy realms, you must interpret nature in a convincing manner. Therefore, you must go into nature to sketch and photograph its beauty to use as reference. Each of us has our own unique imaginings of what the fairy worlds should look like, but real elements from nature form part of these worlds of fantasy. Don't hesitate to express your ideas and perhaps create worlds of fancy never before seen.

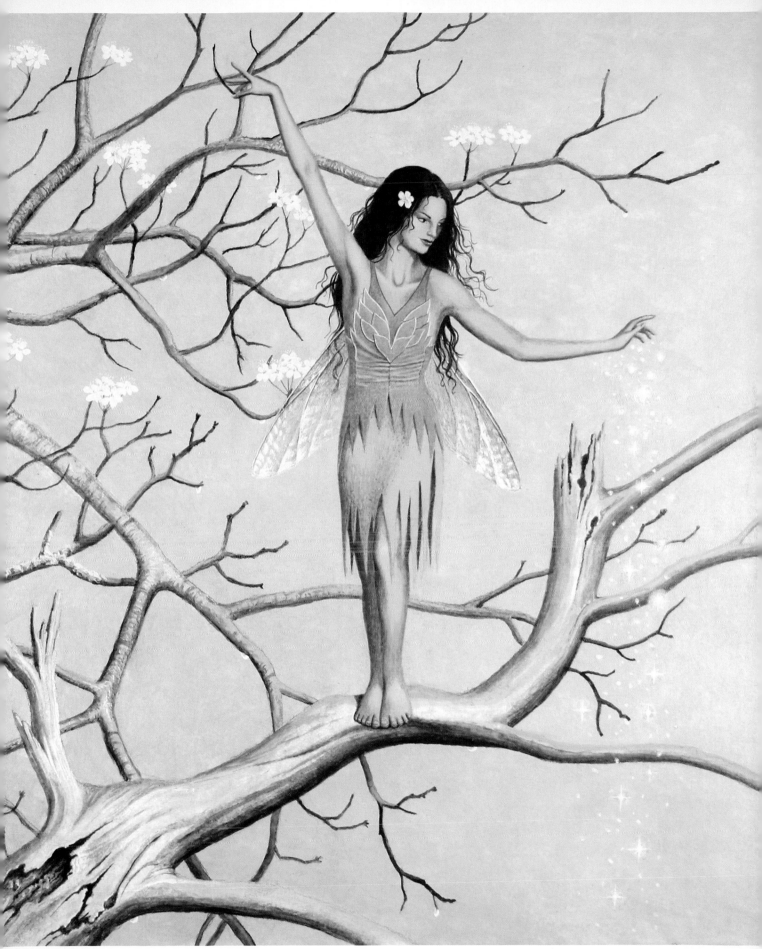

Spring Dusting (Fairy Dust)
Acrylic on illustration board
11" × 14" (28cm × 36cm)

Paints

Acrylic paints come in a huge variety of colors. This can be overwhelming at first, so, to begin, select a range of basic colors. The hues you choose to paint with are ultimately up to you and may give your paintings a special look or style, but it's the way you use them that will set you apart from other artists.

I primarily use a typical landscape palette—all the colors I need to interpret nature realistically. My secondary palette contains colors for painting portraits. Start with a limited palette, then gradually include other colors. Some will become your favorites while others will rarely be used.

Keep in mind that acrylics dry very quickly and will become darker in value than the mixture on the palette. So, it's important to mix more than you need since the dried color on the painting support will be difficult to match.

I tend to use gesso instead of white when making mixtures for light passages, tints or high illumination. Gesso is more fluid than pigments and flows off the brush wonderfully. Paint mixed with gesso is especially useful for illuminating fairies.

My Palette

I mainly use Liquitex acrylic paints (although I also use Golden and Daniel Smith). My primary palette includes:

Ivory Black

Titanium White

Payne's Gray

Raw Umber

Burnt Umber

Raw Sienna

Burnt Sienna

Chromium Oxide Green

Vivid Lime Green

Emerald Green

Yellow Oxide

Naples Yellow

Cadmium Yellow Light

Cadmium Yellow Medium

Cadmium Red Light

Cadmium Red Medium

Alizarin Crimson

Dioxazine Purple

Ultramarine Blue

Ultramarine Blue (Green Shade)

Prussian Blue

Brilliant Blue

Light Blue Permanent

Gesso

Gesso resembles paint, but it's thinner and dries harder. It mixes easily with acrylic paint, or you can apply it thinly over acrylics. For sparkles and magical effects, I almost always start with white gesso, then add glazes of diluted colors.

Brushes

The brush is a painter's most important tool. An astonishing assortment of shapes and sizes of brushes is available. I mostly use red sables and synthetics. Experiment with a variety to find what you like.

no. 4 sable flat

no. 12 synthetic round

no. 10 synthetic round

no. 8 synthetic round

no. 6 synthetic round

no. 10/0 sable liner

no. 00 sable detail

no. 0 sable liner

no. 18/0 sable liner

no. 3/0 sable detail

no. 2 sable round

no. 3 sable round

Fibers

The finest quality brushes available are Kolinsky sables. These expensive brushes are made from the hair of the Russian male kolinsky's winter coat and are sold under many brand names. Artists love this type of brush because of its ability to hold a load of paint, keep its resilience and maintain a sharp point that always snaps back.

I do most of my painting with sables. I especially enjoy painting with small sable brushes. They are excellent for applications of thin washes, fine lines, stippling and crosshatching. Never use these brushes for scrubbing or other vigorous applications—the lifetime of the brush will be shortened considerably.

Synthetics are generally made of nylon fibers. If you're on a tight budget, there are still many quality brushes available. Robert Simmons synthetics are a good choice. They are affordable and durable, and will outlast natural sables.

Shapes

I use flats and filberts to do washes and to cover passages and large areas in my paintings. Glazes can be applied with any brush (I use rounds, flats and filberts). Filberts can produce a variety of strokes. Don't throw away your worn-out filberts—they're very useful for dry brushing. Detail brushes are necessary when delicate brushstrokes are required. Liner brushes have longer bristles than detail brushes and are the perfect tool for painting grass and thin branches, and for outlining fairy wings.

Size

The sizes I use depend on the stage in the painting. I complete details with tiny brushes (nos. 6/0 to 1). For priming and varnishing, use a 1" (25mm) or 1½" (38mm) flat for small paintings and a 2" (51mm) or 2½" (63mm) flat for large paintings.

Brush Care

Clean your brushes thoroughly, or paint will accumulate at the ferrule (the metal sleeve connected to the handle that securely holds the brush fibers in place). The fibers will become weak and break off.

Brushes with natural fibers have to be cleaned with soap. Use a mild bar soap, such as Ivory. After washing, rinse the brushes thoroughly to remove all the soap. If soap residue is left on the fibers, it will act as a repellent the next time you use the brush. Synthetic nylon brushes can be cleaned without soap. The paint will rinse out with just water.

Tools for Self-Expression

The tool you use to create a picture, whether it's a pencil, brush, chalk or stylist, is a conduit for self-expression. You must think of the tool as an extension of yourself so that the image in your mind can easily flow onto the support.

Painting Supports

Painting support simply refers to the surface you paint on. I paint on Masonite, hardboard and hot-pressed illustration boards, all of which I prime with acrylic gesso. Masonite is a trademarked brand name of a board made from wood fibers and glue. Hardboards such as cedar, walnut, mahogany, birch and oak are suitable for painting. I prefer hardboard because it lasts longer than canvas.

I use Ampersand hardboards, which are unprimed high-quality Masonite supports (these can be purchased primed and ready for painting as well). If you prefer to buy sheets of Masonite and cut them yourself, purchase untempered ¼" (6mm) Masonite. Do not choose any material that contains waxes, oils or preservatives, as these additives will affect your painting adversely and drastically shorten the life of the piece.

I prime the front with up to six coats of gesso, sanding each layer with 220 (medium) sandpaper. Allow the gesso to dry for an hour or more, depending on the temperature and humidity level of your environment. I like to mix the gesso with Liquitex acrylic Payne's Gray and Raw Umber or Burnt Umber to make a toned ground on the support. For nighttime scenes, I'll sometimes prime the support with black gesso.

I also apply a coat of gesso to the back to assure non-warping, leaving a margin around the perimeter for a cradle (¾" [19mm] to 2" [51mm] frame parting strips) to be glued to the support.

Painting Supports

Cradled Boards

Painting boards can be cradled or uncradled. I paint on both; the small formats are left uncradled (as these are as small as 5" × 6" [13cm × 15cm]). Cradled boards give the support more strength and prevent warping. Large formats should always be cradled.

Other Painting Supplies

Here are a few more simple tools you'll need for painting and storage.

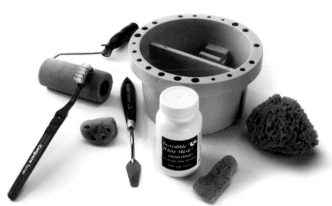
Painting and Mixing Tools

Painting Tools

A natural sponge is a great tool for covering passages quickly, but it's important to brush over sponged areas with dots, dabs and dashes to further detail and refine the forms. I use these to create textures in rocks, moss and the leaves of trees and shrubs.

I use toothbrushes to stipple paint onto rocks and sand. The thousands of tiny dots created with a toothbrush enhance the texture of these surfaces. It can also work great to quickly create a starry night sky, but you must practice to create this illusion correctly. Dab the brush into a very thin pool of paint so that when you flick the bristles with your thumb, you create dots of paint rather than splats.

Masking fluid is a water-resistant fluid that preserves the detail on a support, allowing you to paint around an area without fear of overpainting.

Mixing Tools

To mix colors, I use a painting knife rather than a palette knife. Painting knives can be used in lieu of a brush and are available in a wide range of shapes and sizes. The smaller sizes suit me because most of my mixtures and supports are small.

Palette

Palettes

For paint palettes, use butcher's trays, sheets of glass, plastic plates or any other surface that doesn't absorb paint. Use a spray bottle (sparingly) to keep the mixtures moist. You can also try a wet palette. In a shallow butcher's tray, place several sheets of paper towels on the bottom and wet it. Place a sheet of wax paper or strong tracing paper over that. This becomes the surface for mixing. The moist paper towels create a humid environment, slowing the drying time of the paint.

Storage Containers

Mixture Storage

It's often necessary to store your mixtures, especially if you're working on a time-consuming piece. You can use a variety of containers, such as film canisters or those small containers from restaurants that hold tarter sauce, etc. Be sure to dab a spot of color on the lids of opaque containers. Store them in the refrigerator to keep the paint moist.

Palette Storage

If you are going to leave your painting for an hour or more, cover your palette with a damp paper towel, then cover that with aluminum foil. Place the tray in a plastic bag and store it in the refrigerator. It will remain moist for your next session.

Basic Drawing and Sketching

Good drawing skills are the foundation for creating a great painting. Take time to draw in your sketchbooks as much as possible. Make drawing and sketching become a part of you. Drawing improves your powers of observation because, to render form correctly, you are training your mind to see the subtle nuances in nature. The more proficient you become at drawing, the better your paintings will be.

In the visual arts, the mind must be trained through close observation of forms and repetitive sketching. Be patient. There's no simple solution to mastering the art of painting. Follow the advice and instruction of other artists. Closely observe the play of light upon objects and draw them! When you overcome the mechanics of drawing, you'll be sketching and drawing with more confidence and it will be apparent to the viewer.

The most difficult subject to portray is the human body. If the proportions are just a little bit off, it's obvious. Drawing the human body realistically is essential to portraying beautiful, expressive fairies.

Study and sketch the body as much as possible and don't overlook the subtle nuances that make up its structure. The best way to gain an understanding of form is through close observation. Then draw what you see with impeccable attention to detail.

Use references such as models, photographs and magazines. However, do not plagiarize another person's work. Use images as reference to accurately portray something; don't copy them.

As you sketch, concentrate on areas that challenge you the most. Make side sketches and notations of the parts you're struggling with. Don't over-simplify important structural features. Simplifying or incorrectly drawing and painting important parts such as hands or feet will limit your ability to express yourself.

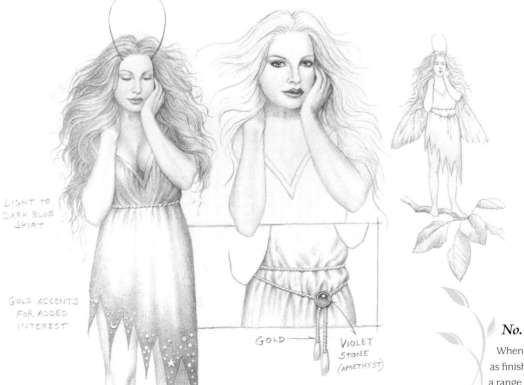

LIGHT TO DARK BLUE SKIRT

GOLD ACCENTS FOR ADDED INTEREST

GOLD →

VIOLET STONE (AMETHYST)

My Sketching Process
Here's a glimpse at my sketchbook. This study is typical of my approach to sketching and understanding form. As I sketched the image on the right, I decided to open her eyes to increase contact with the viewer. Then I elaborated on her garment within a box and included notations to remind me of my thoughts.

No. 2 Pencil
When drawing compositions as finished art pieces, I use a range of pencils, but a no. 2 pencil is quite sufficient for sketching, thumbnail drawing and composing on your support.

Working Process

My ideas for paintings are ultimately inspired by nature. When inspiration strikes, I visualize a finished painting, sketch thumbnails of several ideas and then search through my swap file of photos, sketches and other materials to find images that will help me realize the complete concept.

Thumbnail sketches should be very loose and spontaneous. The purpose of doing these is to work out a composition. Then draw a rough version of the composition until you're satisfied with it. At times, a more detailed preliminary sketch may be necessary.

Find images as reference that will help you clarify the idea. Render a preliminary sketch showing the value structure. Sometimes a separate detailed preliminary drawing (like the one shown below) or a painted study should be done to clearly visualize the finished design.

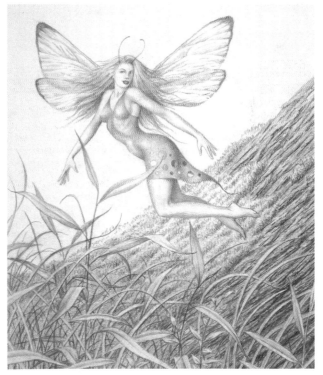

1 Thumbnail Sketches
Render as many thumbnails as it takes until a pleasing design is realized (sometimes up to a dozen).

2 Rough Version
This is a larger sketch of your idea that clarifies the design you have in mind.

3 Preliminary Drawing
This is a detailed preliminary drawing. When I proceed with the painting, I'll make a few changes and additions. Her torso and arms are a bit too long, but I can adjust them easily in the painting. And I plan to paint the background dark. This will give the composition a mysterious atmosphere and allow me to make the scene more magical with points of light and sparkles.

Value

Value (or *tone*) is the light or dark quality in color. It is the most important design element of a painting. Without an accurate value plan, your work will appear flat. Good value structure is very important to the success of a painting.

Every color has a value. Try imagining a color wheel in black and white. You're seeing its range of values, every gradation of gray from light to dark. When you refer to a color's value, you're describing a color as pale, light or dark, its relative lightness to darkness.

Value Scale

A value scale (or grayscale) shows the full tonal range of a color. Again, imagine a scale of color without the hue.

It's in shades of gray—very light to very dark. A color of very light value is almost white. A color of very dark value is almost black.

Recognizing value does take some practice. To simplify the value structure of a painting or scene, squint your eyes until you are looking through your eyelashes. This will help you focus on value rather than hue and other details. Another way to judge the values in a painting is to look at it in dim light. Some artists photograph their work in black and white just to analyze the value structure of their paintings.

100% ← → 0%

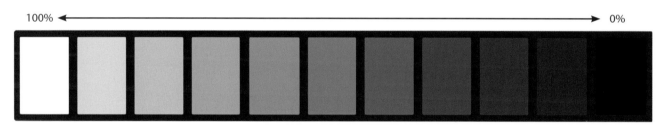

Value Scale

Value scales are usually divided into no more than ten steps, but this one is divided into eleven steps. White and black are sometimes omitted from this range, but I've included them here. The value scale is a useful tool for matching color values. It may be used in the field or in the studio. Hold it up to the subject to match an area with one of the values. You will then be able to paint the correct value structure of your subject. As you become more experienced at painting, you will no longer require a value scale for reference.

"Value-able" Preparations

Begin all paintings with a full-value monochromatic underpainting. Then apply the colors with layers of thin glazes and scumbles. Glaze in the dark values first to lock in the form. Proceed with successive layers of lighter and lighter values. Working this way provides a lot of control. The gradual buildup of value gives structure to the emerging image.

Values in Action

Composing your picture with convincing values will create greater impact. A wider range of tonal values will usually increase this effect. Highlights and shadows attract us to a painting, but it's the full range of tonal values that strengthens it.

As a painter of nature, I'm continually faced with lighting problems. Understanding value structure has helped me a great deal in creating strong compositions. For instance, I have noticed that an object in direct sunlight has a shady side that is approximately 60 percent darker in value than the sunlit side, unless it is affected by indirect light. Pay attention to indirect illumination reflected from other parts of the landscape—it affects the shadow side of objects and will make cast shadows darker.

If the contrast of your painting is low, your picture will appear flat. It cannot be corrected by adding more color; you must focus on the values. Strong value structure will add depth to your compositions.

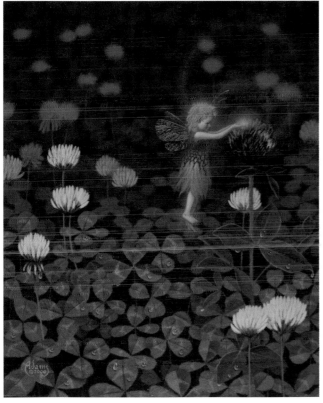

Clover Magic
Acrylic on illustration board
10" × 8" (25cm × 20cm)

Don't Overlook the Importance of Value
Compare these two images of the same painting. Notice the range of tones in the black-and-white image. Rather than focusing only on the colors in your subjects, practice seeing, mixing and painting the full range of tonal values in your subjects. Use a value scale (such as the one on page 18) to help determine the full range.

Basic Principles of Color Theory

The following information and color wheels were provided by my good friend Ana Lúcia Heringer, color theorist, singer, painter and author.

It's important to understand the fundamentals of color. In this section you will learn the basic principles. If you want to dive into a deeper level of study, there are hundreds of books dedicated entirely to this subject.

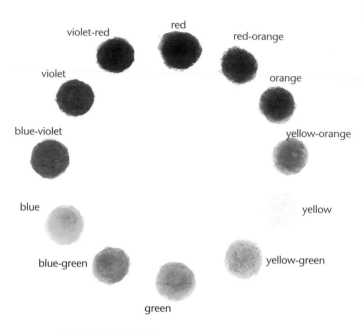

violet-red

red

red-orange

violet

orange

blue-violet

yellow-orange

blue

yellow

blue-green

yellow-green

green

Basic Color Wheel
The *basic color wheel* is a visual tool of color theory. Shown here is a typical color wheel with twelve colors. It is better to use these twelve colors in their pure form than dilute them in mixtures. Undiluted pigment, straight from the tube, has the highest degree of saturation. The colors are more pure and bright, which will help you to achieve better results when combining other colors.

red

blue

yellow

Primary Colors
The *primary colors* combined with other hues can produce a wide variety of colors through their mixes, but they have their mixture limitations. Although modern color theory has proven that cyan, magenta and yellow are the most accurate primary colors, the traditional primary colors (red, yellow and blue) will work fine for our mixing purposes.

Hue
Hue is the name of a color. Red, yellow and blue are all hues.

violet

orange

green

Secondary Colors

The *secondary colors* are orange, green and violet. In theory, they are made by mixing primary colors in equal parts. This is useful information, but you won't find that it's necessary if you buy all the colors mentioned on page 12.

red + yellow = orange
yellow + blue = green
blue + red = violet

red-violet

blue-violet

blue-green

Tertiary Colors

The *tertiary colors* are: red-orange, yellow-orange, yellow-green, blue-green, blue-violet and red-violet. In theory they are made by mixing a primary with a secondary color.

red-orange

yellow-orange

yellow-green

violet-red
red
red-orange

violet
orange

blue-violet
yellow-orange

blue
yellow

blue-green
yellow-green

green

Complementary Colors

The *complementary colors* are hues that are roughly opposite each other on the color wheel. When mixed in equal parts, they tend to cancel each other, making neutral grays and browns. They are very useful in producing neutral colors by an unequal mix between them. When placed side by side, they enhance each other. The warm hue of a reddish object is typically shadowed by its complementary color, green. So, it's better to use one of them in its tints and shades and use the other one (just a little) in its pure tonality, as an accent color. The results are wonderful!

Color Temperature

Painters often refer to colors as warm or cool, hot or cold. The warmth
or coolness of a color is known as the *color temperature*. Some colors seem
to be quite hot and others very cold, but most colors are warm or cool. Reds,
oranges, yellows and violets are warm. Blues and greens are cool.

Each warm and cool color category has its hot to cold temperatures as well. Within the
reds, you will find a hot, brilliant red on one end of the scale and a very cool red on the other
end. When placed side by side, the difference is striking. The cool red contains a little blue, which
makes it cooler. Cool yellows contain a hint of green.

All hues are innately different in color temperature. The visible spectrum of the colors we see
lies between the warm infrareds and the cool ultraviolets. Only a very small range is visible to
the human eye. The wavelengths of light striking the surface of a painting are reflected by the
colors you see on the painting. The warmth or coolness of a color's temperature influences
our choices and placement of colors onto the painting.

Warm vs. Cool
Here are warm and cool comparisons of green
and yellow. Vivid Lime Green (warm) and Chro-
mium Oxide Green (cool) are the greens I use
most often in my paintings. I will occasionally
glaze over Vivid Lime with Chromium Oxide
to create shaded areas to maintain the highest
degree of saturation, but, in many situations, I
reach for a complementary color to achieve the
effect of shade.

A warm yellow such as Yellow Light Hansa
looks very bright next to the cool yellow of
Yellow Oxide. Notice the hint of green in the
cool hue when shown right next to the warm
yellow. Yellow Oxide is an invaluable color for
portraying nature realistically.

Color Saturation

Saturation is the brightness of a color. A hue from a tube of paint is a high intensity color. When a color is mixed with another, the saturation is altered and the intensity is reduced. For example, when white is added to a color, the value of that color lightens.

Colors in their pure form are rarely seen in nature, so you must make mixtures that include other colors and/or white to reduce color intensity. Lighting conditions, atmosphere and any number of other variables affect the colors we see in objects.

Pure colors (high saturation) are most commonly used in abstract works. However, when painting realistic designs, you must continually decrease the saturation of a color by mixing it with other colors. The challenge is to change the saturation without changing its value. Sometimes the solution is to use a neighboring (analogous) color on the color wheel. For instance, if you want a strong green when painting grass, mix in another green instead of blue or red for the shaded areas. But, in most cases, the complementary color is the best choice for reducing saturation.

Cobalt Blue

Cobalt Blue +
Cadmium Orange Medium

Chromium Oxide Green

Chromium Oxide Green +
Cadmium Red

Dioxazine Purple

Dioxazine Purple +
Cadmium Yellow

Reducing Saturation With Complements
Mixing complements is a great way to reduce color saturation. Notice how the second swatch in each of these examples is toned down and less intense.

Fully Saturated Colors
These colors are all purest, most saturated form. Notice the brilliance and high intensity of each color.

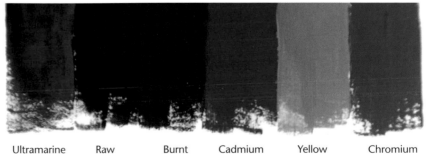

| Ultramarine Blue | Raw Umber | Burnt Sienna | Cadmium Red Light | Yellow Oxide | Chromium Oxide Green |

Mixing Colors

Use as few pigments as possible to create the color mixtures you're looking for. This will create a wonderfully rich painting. Combining too many colors in a mixture will produce mud. Limit yourself to two or three hues in any given mixture. Also, stick with analogous or complementary hues. This will assure you a painting that's rich with color and will help you avoid muddy mixtures.

Mixing Complementary Colors
Mixing Quinacridone Violet with Vivid Lime Green results in a warm shade.

Intensity
Mixing Vivid Lime Green with a neighboring hue, such as Chromium Oxide Green, affects the chroma less.

Darkening Color
Use blues to darken browns such as Burnt Sienna. I used Ultramarine Blue here. For a more subtle darkening, Brilliant Blue is a good choice.

Optical Color Mixing

Optical mixing refers to the way one perceives a third color when two hues are placed side by side or on top of one another. The Impressionists were masters at placing complementary colors next to each other to create the illusion of another color. The pointillist Georges Seurat took optical mixing to the extreme. His large compositions were meticulously designed and painstakingly executed by stippling his canvases with components of individual colors. When viewed from an appropriate distance, the wonderful harmonization of the colors in Seurat's work is impressive.

Rather than juxtaposing colors or using premixed colors from the palette, I create optical blending by overlaying multiple glazes of color. The colors in a glazed painting seem to move toward the viewer from deep inside the picture and within and behind one another. The glazing technique brings out this extra dimension. The effect is much richer than combining colors on the palette. Transparent glazes interact with the underpainting. The light penetrates the layers of color, reflecting back to the viewer in exciting, luminescent colors.

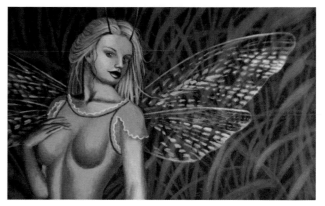

The Effect of Premixed Colors
This fairy was painted using premixed colors. It was more challenging to give the wings a shiny, iridescent appearance. Her skin and hair lack a certain glow that can only be achieved through glazing.

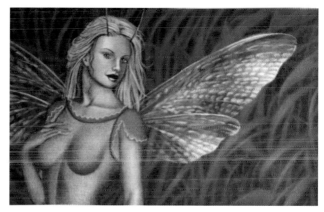

Glazing Results
This example was painted using the glazing technique (see page 28). As you can see, there's more iridescence in the wings and the overall design has a richer appearance.

Glazing vs. Premixing

Try painting an apple, one that's not completely ripe with a bit of green in it. First try painting it with premixed colors, blended on the palette. Use mixtures of yellow, red and green. Then, paint the same apple starting with an underpainting of yellow. Complete the painting with glazes and scumbles of red, green and yellow. When you compare the two, you will be surprised by the richness and inner glow created by glazing.

Toned Ground

A *ground* is the surface on which colors are applied. Supports can be purchased either primed with gesso (a ground ready for painting) or unprimed. I prefer to prime hardboard supports myself because I like to paint on toned grounds. By mixing acrylic paint with gesso, I can easily tone the gesso to the value needed for a composition.

Several coats of gesso are necessary to establish a good ground. It's important to create a nice, even texture. It is always better to apply coats of thinned gesso rather than one thick coat, as this will add strength to the ground you create.

I usually create toned grounds by mixing pigment with white gesso. A white support can sometimes be too bright to the artist's eyes, making it difficult to begin a painting. When painting on a toned ground, judging the values of your painting becomes easier, as you are not dealing with the strong contrast of a white surface. Traditionally, toned grounds tend to be warm, but any color can be used.

Applying a Ground
Mix Burnt Umber with gesso to create a creamy color. Thin the mixture with water to create a syrupy consistency. Apply the mixture with a large brush. Shown here is a 1-inch (25mm) sable flat. Nylon bristle brushes are also a good choice. Brush it onto the support quickly in the same direction. Then use a roller while the gesso is still wet.

Then set the support aside and allow it to dry. Allow at least an hour with the support lying flat. You may speed up the drying process with a hair dryer.

Using a Roller
Use a spongy roller to roll over the support both horizontally and vertically until all brushstrokes are gone. Gesso dries fast, so, if you're priming a large support, use your judgment to divide the application in segments.

If tiny bubbles appear, simply pop them by blowing over the area with a hair dryer or very lightly work over the area with the roller. The texture created by using a roller will enrich your design and your finished painting will glisten in the light.

Sanding
Sanding the support improves the adhesion of the paint film to the surface. I sand my supports lightly with 220-grit sandpaper. Lightly sand the support in a circular motion between each layer of gesso. Try to maintain the texture that the roller produced. Wipe away the dust with a damp paper towel or tissue.

Note
I don't leave the textured surface on very small paintings, as the texture interferes with fine detailing. Sand the surface of small paintings smooth between each coat.

Underpainting

The first layer of paint applied to a support is the *underpainting*. This is the foundation for subsequent layers of paint. The underpainting will influence the overall look of the finished work.

I work in segments—background, middle ground, foreground, then the figure. I find it easier to focus on one area at a time.

Glazes and washes as well as sponging are involved with some underpaintings—it's not just brushwork. I use one to three colors to achieve a full-value underpainting. Limiting your colors to a couple is easier to maintain—there's less work involved when overlaying other hues.

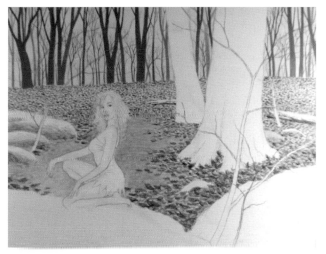

1 Sketch and Apply the First Layers
Draw the design onto the support with a pencil. Next, apply a very thin layer of Yellow Oxide mixed with white gesso over the distant trees. This warm passage allows the toned ground to show through. Painted the trees and the debris on the ground with a mixture of Raw Umber and Titanium White.

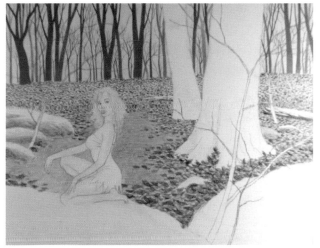

2 Apply Additional Layers and Glazes
Mix a small amount of Chromium Oxide Green with white gesso and glaze over the distant trees and ground. Next, glaze a very thin layer of Ivory Black over some of the trees. Finally, wash white gesso over the trees.

Tip
Save some of the toned gesso mixture in a small plastic container with an air-tight lid. You may need this at times during the painting process.

Glazing

A layer of paint applied over another dry layer is called *overpainting* or *glazing*. The underlying colors optically mix with the subsequent layers, creating a third color (see page 27).

Glazing Basics

Dilute the glaze mixture with water or water mixed with a medium (such as Liquitex Gloss Medium and Varnish). The mixtures should be the consistency of watercolor. The effect is akin to placing a sheet of colored glass over a sheet of colored cardboard. You will be surprised by the richness and inner glow created by glazing. This is an effect that cannot be produced with mixtures.

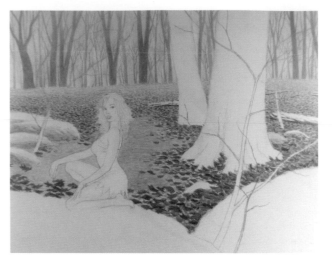

1 Begin Glazing the Middle Ground

Glaze a thin layer of Chromium Oxide Green over some of the trees to move them forward in the picture plane. Next, stipple the debris with dots and dashes of Yellow Oxide, Burnt Sienna, Raw Sienna and a mixture of Yellow Oxide and Cadmium Red Medium.

Glaze the middle ground with the Yellow Oxide/Cadmium Red mixture. To maintain the feeling of distance, glaze the distant middle ground with Chromium Oxide Green and gesso mixture.

A Defense of Black Pigment

Some artists argue against using black pigment. I consider black a color, and I use Ivory Black quite often in underpaintings. The strength of black (with its warmth) in an underpainting is at times more conducive to overlays of warmer colors. I also use Ivory Black in some mixtures, such as with Raw Umber. The black will strengthen its covering power. This mixture is perfect to use in an underpainting for the crevices of the bark of a tree.

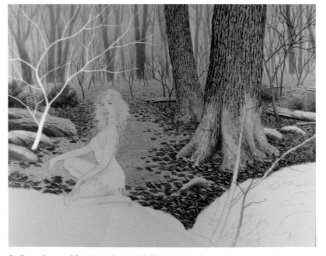

2 Continue Glazing the Middle Ground

Glaze the middle ground again with Ivory Black, Chromium Oxide Green and gesso mixture. Stipple the ground with Chromium Oxide Green and Yellow Oxide and add a glaze of the Chromium Oxide Green mixed with white gesso.

Next draw lines on the two large trees to suggest bark. Then, glaze a full-value underpainting of Raw Umber, Ivory Black and Burnt Umber over the tree trunks. Glaze the rocks with Ivory Black, Light Blue Permanent and Raw Umber.

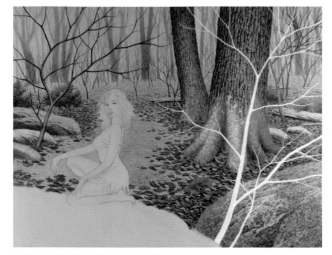

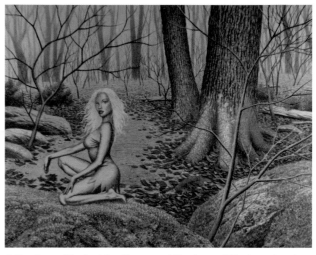

3 Glaze the Tree Trunks and Rocks

Continue glazing the tree trunks with Ivory Black, Chromium Oxide Green and Ultramarine Blue. Then, apply a thin glaze of Raw Umber to bring out the proper look of the tree bark. A stipple of the toned gesso on the bark defines its texture.

Glaze the rock on the right with Ivory Black, then sponge it with Light Blue Permanent, Raw Umber and a mixture of Yellow Oxide and Titanium White. Brushwork defines the rock.

Glaze the other rocks with Chromium Oxide Green, then stipple them with Vivid Lime Green, Cadmium Yellow Light and Cadmium Yellow Light mixed with Titanium White. Use Emerald Green and Chromium Oxide Green for the dark areas.

4 Continue Glazing the Trees and Rocks and Underpaint the Fairy

Glaze the foreground tree with Ivory Black and Raw Umber. Combine Raw Umber and a bit of white gesso to highlight the tree; use a thin glaze of Chromium Oxide Green as well.

Paint the foreground rock the same way as the other rock, except with Naples Yellow and Burnt Sienna. Glaze Burnt Sienna over the dark areas of the moss, then stipple the moss with Naples Yellow.

Underpaint the fairy with Burnt Sienna.

Using Sea Sponges

When using a natural sea sponge for painting, get it wet first, then squeeze out all the water (it should be damp, not wet). Smear the sponge into the paint—no dabbing! Inspect it to make sure there's no thick globs of paint, then carefully pat the painting surface with your sponge.

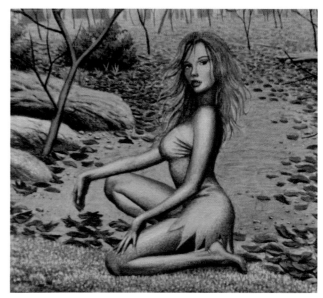

5 Begin Glazing the Fairy

Glaze the light areas of the fairy with Cadmium Red Light mixed with Titanium White. Use Raw Umber for the dark areas and underpaint the hair with Burnt Sienna.

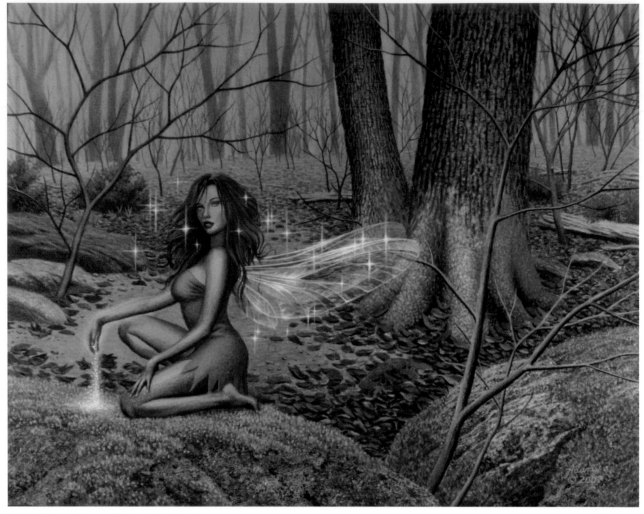

6 Finish the Fairy and Glaze the Wings

Glaze the darkest areas with Cadmium Red Medium and further refine the flesh tone with glazes of Cadmium Red Light mixed with a bit of Titanium White. The slight mixing of contrasting values creates an even blending.

Ivory Black and Raw Umber strengthen the dark values of the hair. Then, glaze Burnt Sienna over that and apply Raw Sienna and Naples Yellow to define the hair.

Glaze the skirt with Chromium Oxide Green, Vivid Lime Green and Cadmium Yellow Light mixed with a touch of Titanium White. Glaze the darkest shades with Payne's Gray.

Use a liner brush and Titanium White to line the skeletal structure of the wings, then glaze the wings with Titanium White to create sheen. Glaze Vivid Lime Green and Cadmium Yellow Light over specific areas to amplify the reflected light. Paint the sparkles using pure hues of Cadmium Yellow Light, Naples Yellow and Vivid Lime Green. Finally, cross white gesso at the center of the sparkles.

Final Notes on Glazing

The values in a painting can easily be adjusted by controlling the thickness of the glaze. Glazes are typically dark, so it's best to paint over a lighter underpainting. Thinner is better, not only because the underlying colors will show through, but also because the light can easily pass through the layers, creating luminosity. However, at times, it's useful to add a small amount of Titanium White to the glazing mixture to give the mixture greater stability to further define the subject. (When this mixture is used, the technique is actually a scumble rather than a glaze.)

When selecting a color for glazing, remember to thin down opaque colors (like Cadmium Yellow). An opaque color applied thickly is not a glaze—it's a scumble. All colors can be used for glazing as long as they're thinned down enough to allow the layers of color below to show through.

Scumbling

Scumbling is just like glazing except with thicker layers of paint. The illusions of fog, mist and clouds are created by scumbling layers of color over one another. The initial colors are sometimes totally covered by scumbled applications.

Creating Clouds

Clouds are created by applying layers of scumbles, except in the case of cirrus clouds, in which thin layers of glazing are involved.

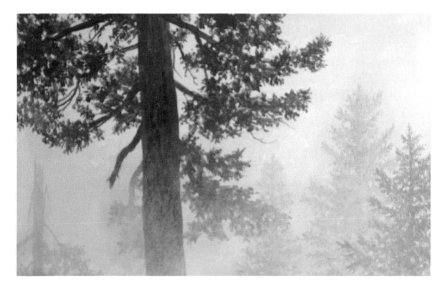

Creating Fog

To create fog, paint the background trees first, then scumble over them with a gray mixture. Paint the foreground last and scumble very lightly over that. I painted all the trees in this painting with the same mixture; the extent to which each tree was covered by scumbling placed the trees at different levels within the painting.

Linear Perspective

Linear perspective is the way of showing depth and distance on a flat surface, such as a drawing. Perspective using one, two or three vanishing points may seem different, but all three are mathematically identical because of the relative orientation of the straight lines of the scene. These basic principles of perspective will be useful for accurately foreshortening structures and objects within your fairy scenes.

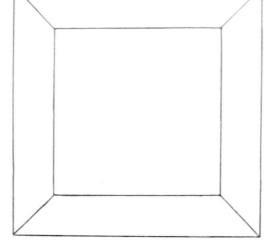

One-Point Perspective
One-point perspective is used for objects viewed from the front. Objects in one-point perspective are made up of lines parallel or perpendicular to the viewer (all linear elements intersect at right angles).

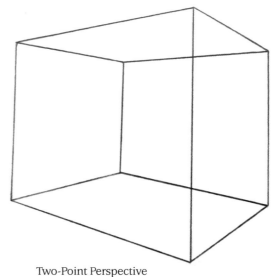

Two-Point Perspective
Two-point perspective is used for buildings that are seen at the corner. The walls of a building recede toward two vanishing points.

Vanishing Points
Vanishing points are the imaginary points (usually on the horizon line) toward which parallel lines in a scene recede.

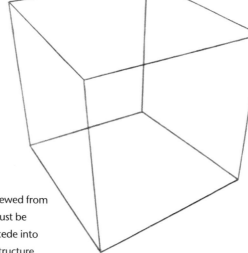

Three-Point Perspective
When depicting a tall building viewed from above, a third vanishing point must be added to show how the walls recede into the ground. When viewing the structure from the ground, the third vanishing point is high above the building.

Atmospheric Perspective

Leonardo da Vinci was instrumental in calculating and then employing a system for painting landscapes realistically. An important part of this system included *atmospheric (or aerial) perspective*, the use of color and value contrasts to achieve a sense of depth in a painting.

How it Works in Life

Atmospheric conditions influence our perception of distant objects. Gaseous molecules, dust and water particles in the atmosphere affect the intensity and saturation of color in distant forms, making them appear cooler and lighter. Tonal contrasts in the distance are subdued.

The lack of contrast, detail and texture is a visual signal to the brain. Objects exhibiting these characteristics are understood to be far away.

Fading Into the Distance
Notice how the distant landforms seem to almost disappear into the surrounding atmosphere.

Learning From Life

Leonardo would often trek to the countryside in the morning light just to observe the landscape. He took note that nearby mountains were more distinct and the distant mountains were bluer and less distinct. Essentially, the far distant landforms took on much of the color of the surrounding atmosphere, giving them a bluish hue. These observations led to the development of atmospheric perspective in painting.

How It Works in Painting

Using atmospheric perspective alone will give the impression of distance. Add more blues to distant objects and add very light hues or white to subdue the colors. A bold foreground will add more interest and invite the viewer into the scene. Clear, sharp foreground forms with strong contrast create the illusion of more depth within the painting.

Color affects the perspective and mood in a painting. Blues and purples recede, while reds and yellows advance. This is not to say that a warm colored object such as a red barn should not be placed in the distance. Just reduce the intensity of the color to subdue the reds of the barn.

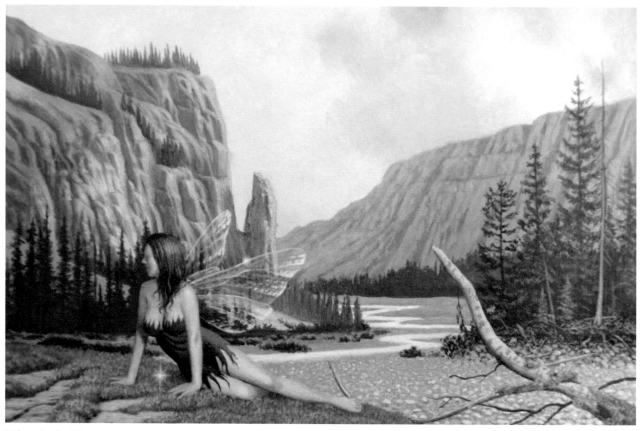

Values in the Distance

This is a good example of atmospheric perspective. Notice how the strong, dark values of the foreground, in relation to the light values of the distance, capture your attention and draw you into the picture.

Atmospheric Effects on Local Color

When you look at an object, the color you see is not its true or local color. Light, shadow and reflection greatly affect our perception of an object's actual color. Atmospheric conditions incrementally lower a color's value, hue intensity and saturation in relation to its distance in the picture. Capturing the atmospheric effects accurately will add depth and realism to your painting.

Using Atmospheric Perspective in Your Own Paintings
Here's an example of how atmospheric perspective might come into play when painting a brown tree trunk. In the foreground, this brown tree trunk will appear brown. That same tree trunk placed in the middle ground will have much less intensity, appearing orange, purple or maroon.

Farther in the distance the trunk will appear more blue than brown.

When composing your painting, keep in mind the subtle nuances of color. The intensity of each mixture must correlate with its placement on the picture plane.

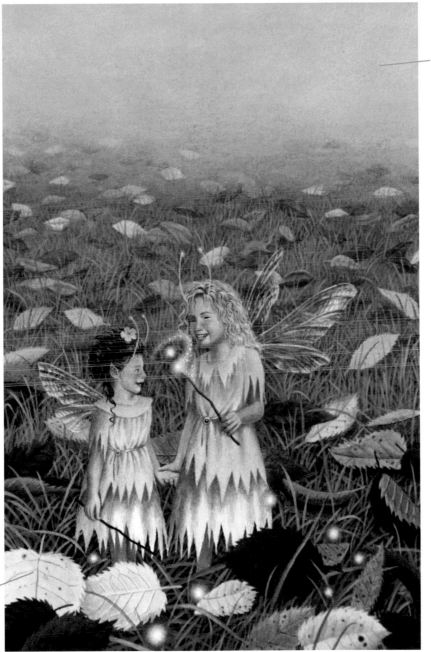

The distant leaves and grass were subdued by scumbling over them with a gray mixture, creating a foggy effect.

The foreground was painted with pigments of the purest saturation.

Control Color Intensity for Greater Realism
When depicting fairies in a landscape realistically, the surrounding objects should be subdued. The saturation of color gradually decreases as objects recede into the background.

Overlapping

The spatial concept of *overlapping* is crucial in painting as it helps to create the illusion of depth. The overlapped objects (partially obscuring other forms) give the perception of objects being farther back in the picture plane.

Most overlapping occurs in the foreground and middle ground of the painting where the background objects are obscured. You must overlap the forms convincingly and merge them with the background to create a believable sense of depth.

Three-dimensional space is often taken for granted. As an artist, it's important to think spatially so that you can impart the illusion of depth to the viewer.

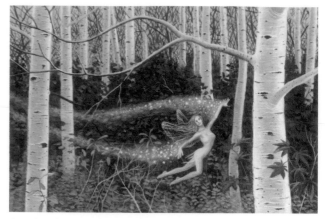

Overlapping Landscape Elements
This painting shows the overlapping of objects as they recede into the distance. The trees decrease in size as they recede, also adding to the depth in this painting.

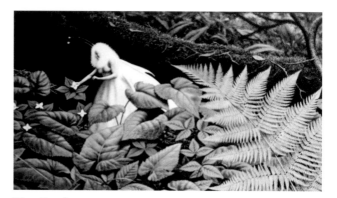

Tiny Overlaps
Although this painting shows a microcosmic view of the fairy world, the overlapped objects still display a sense of depth.

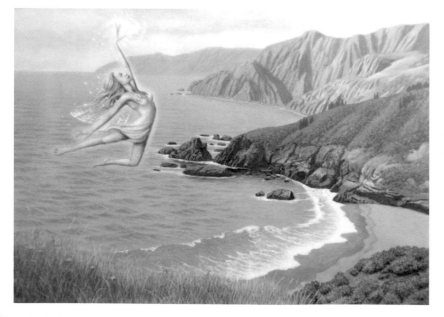

Overlapping Landforms
The mountainous fingers of the coastline overlap one another, creating a sense of distance and great depth. The bit of foreground overlapping the shore and sea is much more detailed than the rest of the picture, adding to the sense of depth.

Composition

Composition is the arrangement of the visual elements of a painting into an ordered scheme. A composition contains an infinite number of variables. Color, shape, line, texture and value all work together and interact with one another in a relational organization to create an interesting picture. Good orchestration of the elements affects the principal aspects of harmony, contrast, balance and rhythm. Certain strategies can focus the viewer's attention on important elements in a painting.

The Rule of Thirds

All successful paintings have one area that stands out more than the rest of the picture, and the main subject is placed there. So where is that sweet spot? An easy way to locate it is to use the *rule of thirds*. It's a tool to visualize the picture plane divided into thirds horizontally and vertically. The four intersecting lines are known as *focal points*. To create a pleasing composition, place your center of interest at or near a focal point.

Limit the center of interest to that one area. Any more than this will create conflicting elements in your design. You can get away with a secondary center of interest, but make sure that your major focal point is up front in volume, size and shape. Sometimes artists break the rule of thirds in order to better express a certain emotional or psychological message to the viewer.

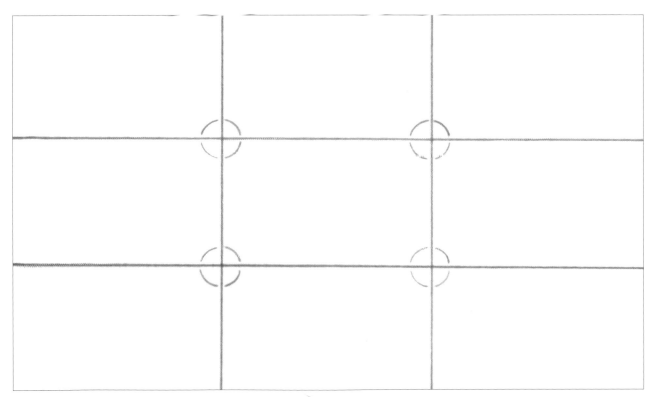

The Rule of Thirds
This diagram of the rule of thirds shows where the focal points are located. The horizon line in a landscape painting is often placed along one of the horizontal lines.

Composition Metaphor

"The foreground is like the door to the composition, so it should have the biggest value and color temperature contrasts and the highest intensities to invite viewers in. The middle ground contains the important things the viewer came for, so it should be more subtle, like a pleasant conversation going on in the main room of the house. Finally, the background is like the walls of the house, supporting the middle ground, so it should possess little contrast or intensity."

—Aleksander Titovets

Juxtaposition

The *juxtaposition* of form within a composition is simply the placement of objects in close proximity to one another. Artists use this technique to create meaning in their paintings. Objects placed next to each other will play off one another. The rhythm created adds excitement and interest, especially if the value contrast is strong. The objects should vary in size and not compete with the center of interest. Juxtaposition is simply a dance within a painting; it moves the viewer's eye through the composition to be graced with the main subject.

Tenebrism

Strongly contrasting light and shadow in an image is *tenebrism* (a combined Italian word meaning "light" and "shade"). Artists use light in this manner to express strong emotion in their paintings. The midtones are always reduced in these works. The application of reflected light will further strengthen the effect. The Baroque artist Caravaggio is well known for his dramatic use of tenebrism. The goal in using this technique is to impact the viewer with drama.

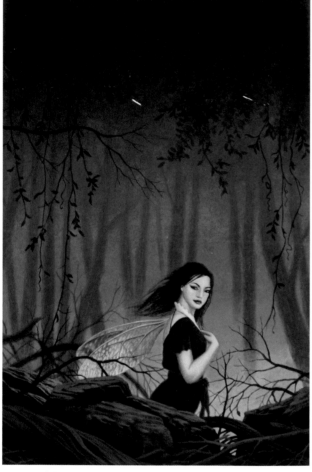

Juxtaposition
The vines, branch debris and background tree trunks are juxtaposed in various ways to frame the center of interest, the fairy.

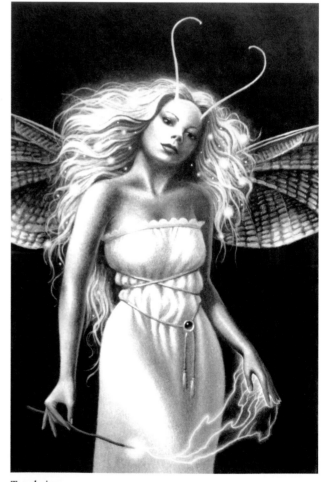

Tenebrism
The dramatic lighting gives the viewer a sense that the figure is emerging from the darkness.

More Composition Tips

After placing your center of interest in a pleasing location, arrange pathways to draw the viewer's eye to that sweet spot. This is what we came for, so capture our attention! To maintain the importance of the center of interest, this area should not be blocked (do not diminish its importance). This is the most predominant spot in the painting; the surrounding areas are subordinate.

Further improve a composition by emphasizing drama or emotion with the use of color at the center of interest. Complementary and contrasting colors in and around this area will lead the viewer's eye to that portion of the painting. If possible, use strong colors and value contrast.

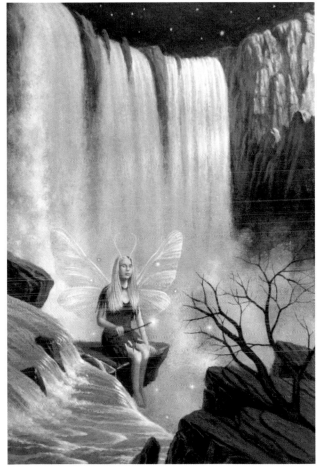

Emphasizing the Center of Interest
This painting uses value contrast and lines to draw the viewer's attention to the center of interest. The main subject is located at a focal point, and other forms and lines in the composition directly or indirectly point to the center of interest. The background detail is minimal as to not compete with the focal point.

Although the sweet spot is front and center, the foreground should be treated with equal respect. It is the doorway into the composition and should be painted strong in value, temperature and intensity. A strong foreground will catch the viewer's attention and invite her in.

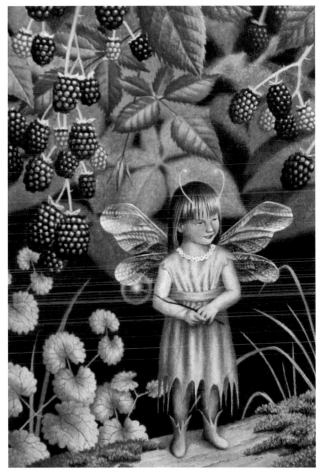

Framing the Center of Interest
The rhythmic dance of the berries and leaves gently frames the center of interest. This design is full of activity, yet does not distract the viewer from the focal point of the composition.

Sources of Inspiration

A variety of sources will conjure ideas for paintings: the morning dew on a leaf, the rays of light beaming through tree canopies, the play of light on a waterfall, the setting sun, an image in a magazine, a scene in a film or even a spoken word from a friend.

2

Drawing and Painting Magical Fairies

Understanding the human form is of the utmost importance when painting fairies. The key word here is form! As artists, there's no need to study the deep anatomical structure of the human body (that's for surgeons). However, it is necessary to know the basic surface musculature and the underlying bones they are attached to. I suggest that you purchase a book on anatomy for artists and keep it handy for reference as you draw your figures.

Humans are the most recognizable objects in our visual experience. Any variance in the delineation of the body will be noticed. The artist must focus on the subtle nuances of light and shadow that play upon form. So, to paint fairies well, study the structure and movements of the human form and record them in your sketchbook. Observe the play of light that dances across the body. If you can render this convincingly, then you're ready to paint a beautiful fairy.

Building on this section's lessons on drawing and painting fairies, you'll then get a chance to put it all together in a few demonstrations focusing on fairy figures.

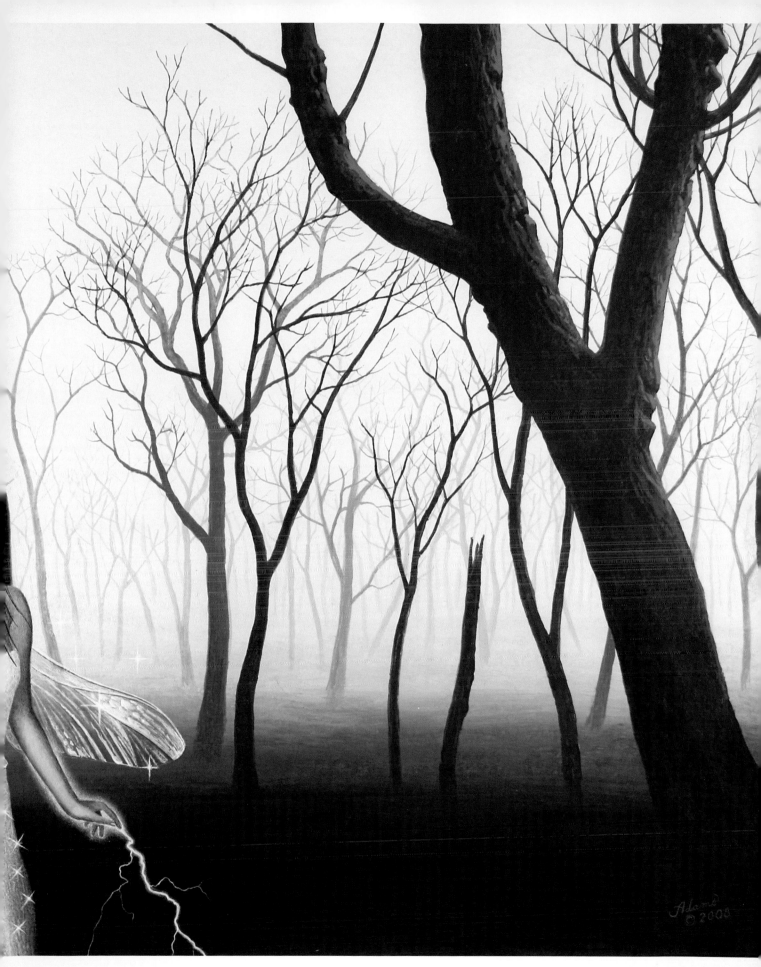

Electrified
Acrylic on illustration board
11" × 14" (28cm × 36cm)

Fairy Features

The following images show features of a fairy that often present challenges. Familiarize yourself with the structure of form and all its subtleties. Sketch and draw any elements of a subject that are challenging to you. If you can successfully render something with a pencil, then you'll be able to paint it.

Eyes

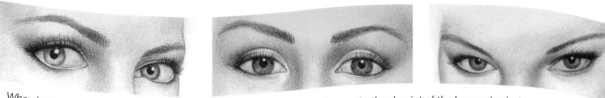

When looking at a painted figure, the first thing we notice is the eyes. They're the focal point of the human body. Here are three different types. Notice that the whites of the eyes are shaded. This is more realistic and accentuates the highlight.

Ears

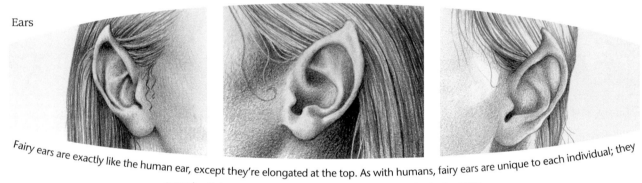

Fairy ears are exactly like the human ear, except they're elongated at the top. As with humans, fairy ears are unique to each individual; they come in all shapes and sizes. But all ears have the same basic structure.

Lips

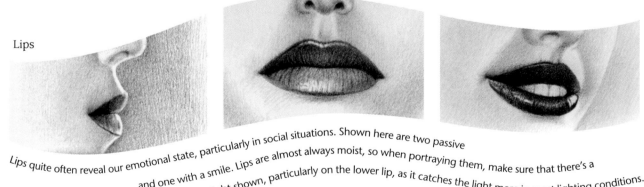

Lips quite often reveal our emotional state, particularly in social situations. Shown here are two passive and one with a smile. Lips are almost always moist, so when portraying them, make sure that there's a highlight shown, particularly on the lower lip, as it catches the light more in most lighting conditions.

Hands and Feet

Sketch the human form as much as possible, and pay special attention to areas that are most challenging to you.

Hands and feet can be particularly troublesome. Follow the exercises below to practice drawing these difficult parts of human anatomy.

Drawing Hands Realistically

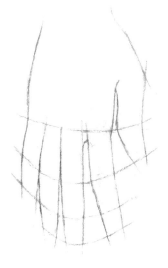 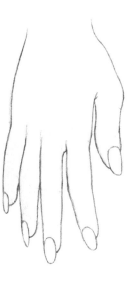 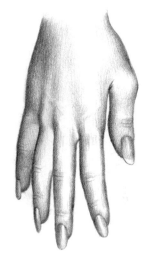

1 Draw the Outline
Draw a basic outline, showing the divisions of the form. Take note of the length of each finger.

2 Develop the Outline
Work on the outline to suggest its form. Fingers taper down from the second knuckle and the base of finger nail emerges half way down the third knuckle.

3 Shade the Hand
Apply the shading. Focus on the dark shades and creases or wrinkles. The light source here is coming from the right, so the shading is on the left side. Establish the middle tones and lightly shade in the subtle contours.

Drawing Feet Realistically

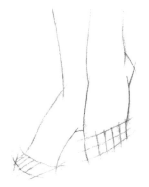 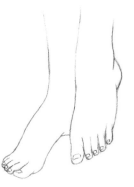 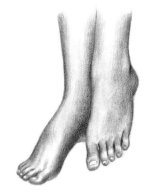

1 Draw the Outline
Lightly sketch simple guidelines to indicate basic feet structures. The foot arcs out from the ankle and swoops down to the toes.

2 Develop the Outline
Work on the outline to suggest a realistic form. Erase the guidelines and focus on the outline contours. Pay close attention to the toes, as they always curve downward.

3 Shade the Foot
Shade in the middle tones and lightly shade areas indicating the contours to finish the drawing. The light source here is coming from the front.

Drawing the Basic Female Figure

Rendering the figure's proportions accurately can be challenging. A simple solution is to use the head length as a unit of measure. The typical (adult) human form measures eight head lengths from the top of the head to the feet, though this varies. The midpoint falls at the hip. The midpoint from hip to feet is the knee.

Female figures have softer features and less pronounced musculature than males. When drawing a female figure, focus on the gentle contours of the figure where light and shade reveal the subtle nuances of form, yet don't pronounce the underlying muscle tissue.

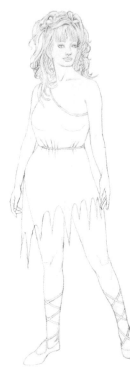 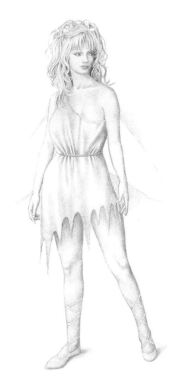

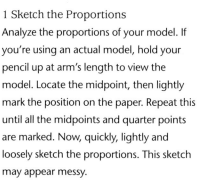

1 Sketch the Proportions

Analyze the proportions of your model. If you're using an actual model, hold your pencil up at arm's length to view the model. Locate the midpoint, then lightly mark the position on the paper. Repeat this until all the midpoints and quarter points are marked. Now, quickly, lightly and loosely sketch the proportions. This sketch may appear messy.

Compare the drawing with the model and make adjustments. Erase all irrelevant lines, leaving just the critical lines for the outline of the figure. Remember to keep all your lines lightly drawn.

2 Shade the Darkest Areas and Develop the Details

Establish the dark areas of the drawing. The light source is coming from the front/left, so the darkest shading is on the right. All outlines closest to the light source should have a value no greater than the area that is outlined.

Carefully line and darken one section of the hair at a time. Complete the eyes and the lips next. Then, establish the dark values of the flesh. Shade gives this fairy's clothing a shiny appearance. Finish by lightly shading in the midtones. Create the straps of the shoes by carefully shading the legs on either side of the straps.

3 Complete the Midtones and Details

Complete the midtones of the hair and flesh next. This makes the figure pop, giving her more realistic form. Lightly outline the wings and shade the background.

After lining the wings structure, shade between the lines. Then shade the background to make the wings pop, gracing the figure with a more three-dimensional look. Do some erasing on the leading edge of the right wing to create a glow.

Drawing the Basic Male Figure

The musculature of men is much more pronounced than that of women. Men tend to have narrower hips and broader shoulders then women, giving the typical man a V-shaped torso rather than the curvaceous shape of a woman.

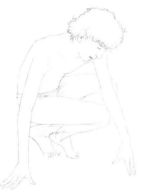

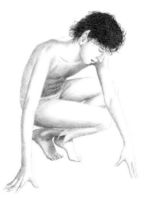

1 Sketch the Proportions
The procedure for drawing a male figure is the same as that of the female figure: establish the proportions, lightly sketch until you're pleased with the outline, then erase unnecessary lines.

2 Shade the Darkest Values
The light source here is front/right, so the darkest values are shaded on the left side of the figure. Define the hair first, then the eyes and lips. Lightly draw some veins in the arms, then shade in the dark values of the skin and clothing.

3 Shade the Midtones
Lightly shade the midtones. Carefully overlap the shading into the dark values. Draw the wings and lightly shade the background.

When shading the midtones, the value structure of the design changes. It's often necessary to further darken the deep shadow areas. It's a process of moving back and forth between dark and light values until you achieve a believable value structure.

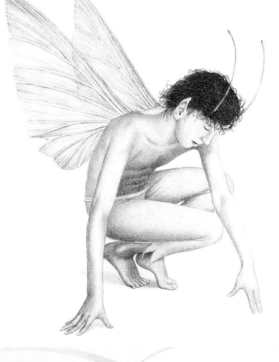

4 Add the Wings and Other Details
Render the wings with lines and shading. Shade around the figure and add a bit of cast shadow at the feet anchor the design into the picture. Darken the area behind the figure to add a feeling of space.

Skin Tones

Skin tones range from very dark to almost white. The amount and type of pigment in the skin determine the skin color. The skin tone of men is usually darker than women's. Brown or black skin tones take more time to paint and require the addition of green or blue for the shaded areas to achieve darker values.

I usually paint fairies with typical human skin tones. However, sometimes I paint fairies with green or blue skin. I make complexion choices based on what I think will look best in a composition. Sometimes, I want the fairy's skin to coordinate with other colors within a design, and other times I want an abrupt contrast.

Light Skin
To paint light skin, start with an underpainting of thin layers of diluted Burnt Umber, then sparingly layer thin glazes of Cadmium Red Light. To create the freckles, dot the skin with Raw Sienna and Raw Umber.

Yellow Skin
Create skin with yellow tones by glazing layers of Raw Sienna over a Raw Umber underpainting. Glaze some Cadmium Red Light over the nose and ear. Add a highlight to the nose with Titanium White.

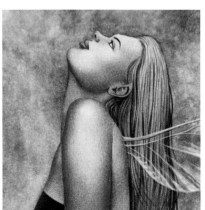

Green Skin
To create green-toned skin, glaze Chromium Oxide Green over a Burnt Umber underpainting. Apply layer after layer until you achieve the appearance you want. Apply Cadmium Red Light to the lips and ear.

Dark Skin
For dark skin, start with an underpainting of three to five layers of Burnt Umber, then glaze Raw Sienna. Then, thinly glaze Ultramarine Blue in the darkest areas. Apply Cadmium Red Light to the lips. Paint the highlights with diluted Titanium White.

Eye Advice
The white part of the eye (sclera) is (almost) never pure white—it just doesn't look natural! Apply very thin glazes of Raw Umber, Ultramarine Blue or Payne's Gray. The color you choose depends on the color scheme of your design. If the design is predominantly blue, go with blue or gray. If the color scheme is warm, go with a brown. Then glaze a bit of Cadmium Red Light at the corner of the eye.

There is a wide variety of hair types and hair colors in the world of fairies. The color of the hair for your fairy is up to you. It can be painted blue, purple or green if you wish.

Painting hair can be quite challenging. Individual strands of hair all come together on the head and must be rendered as a single mass. When drawing or painting long hair, depict a flow of groupings that show most of the individual hairs toward the bottom and in areas where it veers away from the main mass.

Hair Types

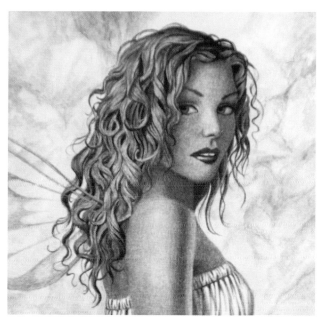

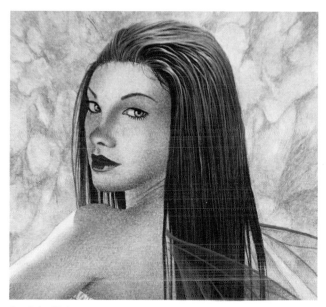

Straight Hair

Begin painting broad strokes with medium brushes. This painting is very small, so I used a no. 8 round sable. Next, use a no. 1 sable, then small no. 12/0 to no. 0 liner brushes to paint the individual strands and small groups. Finally, apply white gesso to create the glossy appearance of long straight hair. I glazed over the gesso with Raw Umber, Burnt Umber and Cadmium Red Light. I used a mixture of Raw Umber and Ivory Black for the underpainting.

Curly or Wavy Hair

The key to painting curly hair is to start with a detailed drawing. Draw groups of C- and S-shaped curls to lay out the overall mass. (Use looser C- and S-curves for wavy hair.) Then, proceed with the underpainting. I glazed Burnt Umber and Raw Sienna over an underpainting of Raw Umber to create this fairy's dark blond hair.

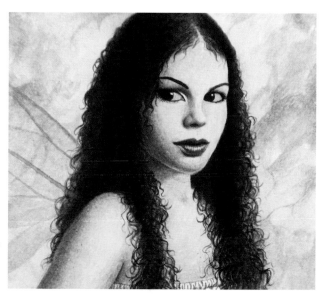

Very Curly Hair

Start with an underpainting of Raw Umber and Ivory Black. Next, paint small curls around the perimeter with Raw Umber and Raw Sienna. The lighting here is like that of an overcast day, which makes it easier to paint. There is no direct light source. Dark, very curly hair without direct light affecting it reveals very few (if any) light spots on the hair.

Fairy Wings

Examine the wings of insects and use them as models for fairy wings. Stylize the structure to fit your vision of your fairy. Most of the wings I create are translucent. Explore other options—butterfly and moth wings are good choices; feather wings are fine, but they could make viewers mistake your fairy for an angelic being. Give your fairies wings that speak immediately tell the viewer, "That's a fairy!"

When drawing fairy wings, the main goal is to make them appear translucent and shiny. The best way to achieve this look is to darken the background behind the wings. The glow and sparkles are primarily produced with erasures.

The wings (if they are translucent) are the last things you depict in a fairy painting.

Drawing Fairy Wings

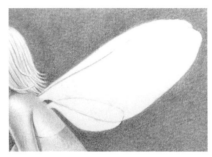

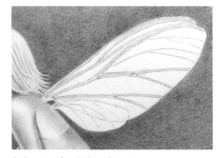

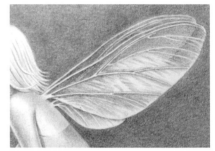

1 Outline the Wings and Shade the Background
Draw the outlines of the wings. Then shade the background. With a few exceptions, it's always best to create a darkened background for fairy compositions in order to show off the translucency and iridescence of the wings.

2 Create the Wing Structure
Carefully render the structure of the wings with lines similar to those of an insect's wing.

3 Develop the Wings' Transparency
Lightly draw the trailing edge of the overlapped wing into the forward wing. This alone will create the look of transparency. Think of the wing as plastic wrap and attempt to capture and reflect light that way. Shade the areas between the lines, leaving some spaces to indicate sheen.

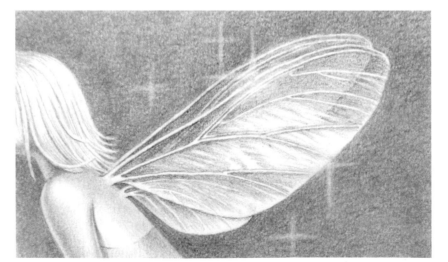

4 Add Sparkles and Magical Effects
Finally, use an eraser to create a glowing effect on the leading edge of the wing. Try dabbing the area rather than rubbing. Repeated dabbing will give you more control over the amount of pencil markings you eliminate. Next, use the sharp edge of an eraser to mark Xs, creating the appearance of sparkles.

Eraser Magic

The use of an eraser is crucial in producing "magical" effects in a fairy drawing. The act of lighting spots after a drawing is completed is a joy and adds to the composition if done sparingly.

Painting Fairy Wings

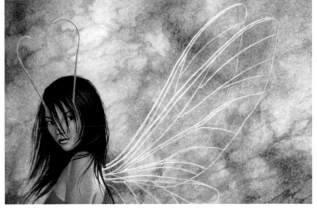

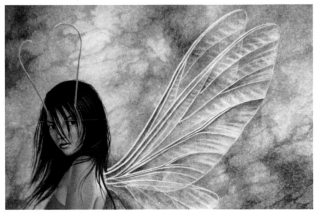

1 Complete the Background and Outline the Wings
Completely finish the background before you start the wings because some of it will show through. Lightly draw the outlines and the insectlike structure. Carefully paint over the lines using a small liner brush and Titanium White or white gesso.

2 Underpaint the Wings
Apply glazes of Raw Umber between the lines. Using diluted Titanium White or white gesso, apply very thin glazes, segment after segment until you've covered the entire wing. Repeat this process until the buildup of layers reveals a convincing ripple sheen. This forms the underpainting for the wings and should always be white.

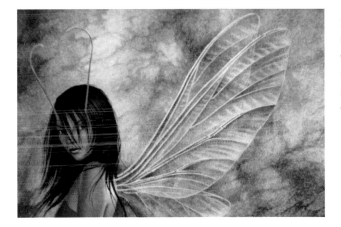

3 Glaze the Wings
Glaze Emerald Green over portions of the wings and mixed Vivid Lime Green with Cadmium Yellow Light to glaze over the area near the fairy's back. I left some areas, which I will illuminate with sparkles.

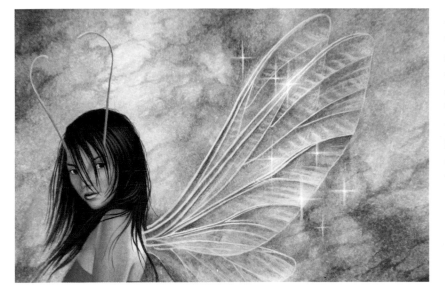

4 Highlight the Wings and Add Sparkles
Glaze a touch of Naples Yellow to either side of the highlights on the leading edge of the wings. Then scumble a few spots on the highlight edges of the wings with Titanium White to soften the lines. Glaze in the sparkles by crossing two lines with a tiny brush and thinned Titanium White. Create a cross at the center of each sparkle with thicker Titanium White.

Flowing Hair

There will be many occasions when you will be faced with the challenge of depicting the graceful movement of long, flowing hair, especially with flying fairies. The movement of long hair, whether brushed by a breeze or caught in the wind or moved by flight, has one constant—it waves in the wind with gentle curves.

Drawing Flowing Hair

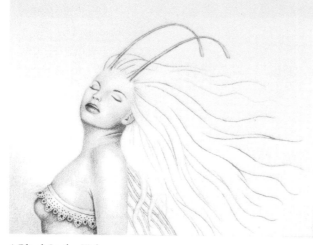

1 Block In the Hair
Draw guidelines to create movement. This element is basically a dance of lines to indicate the look of movement. Very few lines are necessary, as these are simply markings to block in the overall flow of the hair.

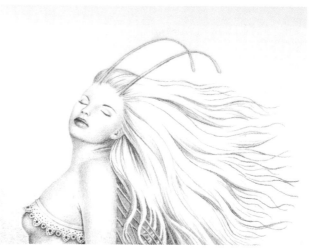

2 Add More Lines and Shade the Darkest Areas
Draw more lines parallel to the initial lines. Then, shade the areas of darkest value. The light source for this drawing is front/right.

3 Complete the Shading and Add More Groupings
Complete the dark values with more lines and shading. Lightly render midvalue lines and midtone shading. Starting from the head, work outward with lines and shading. Taper the hair tips with more groupings and loose S-shape lines.

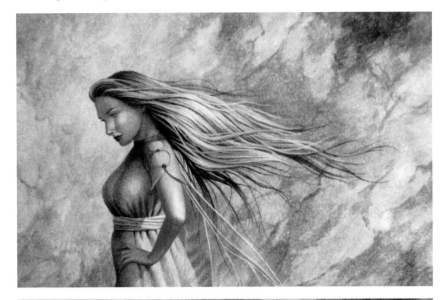

1 Underpaint the Hair and Begin Glazing
Underpaint the hair with a mixture of Raw Umber and Ivory Black for the dark values. Next, apply glazes of Raw Umber followed by glazes of white gesso. This creates the underpainting for the hair. A full-value underpainting is an important step. With the underpainting complete, all you have to focus on is applying thin glazes of color, which requires much less time than the underpainting.

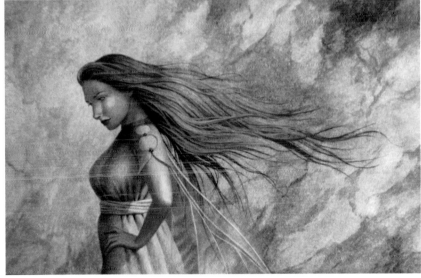

2 Continue Glazing
Next, apply glazes of Raw Umber. Some areas require three or four layers to bring out the full chroma of the umber and to unify some of the midvalues.

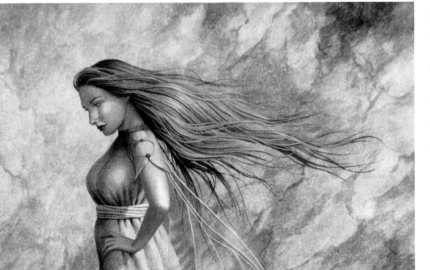

3 Finish Glazing and Add the Highlights
Glaze Raw Sienna over the middle values. This unifies the previous layers of colors. The hair is now ready for the tints and highlights.

Glaze Naples Yellow over the areas where the highlights are to be painted. Next, lightly glaze Titanium White in a few spots to create a shiny look. Finally, add touches of Titanium White to the highlights.

Fairy Clothing

There are no set rules for fairy clothing. It ranges from very sophisticated to very simplistic. Some fairies may opt for no clothing at all! Throughout this book I attempt to show you images of a wide variety of clothing styles. Be imaginative and come up with something wonderful!

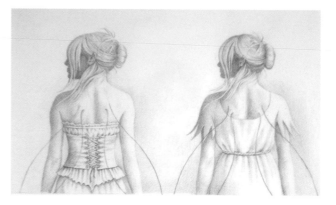

Clothing Around the Wing Area
These two fairies show how clothing fits over the back. As you can see, the area where the wings join the scapula is bare.

Drawing Fairy Clothing

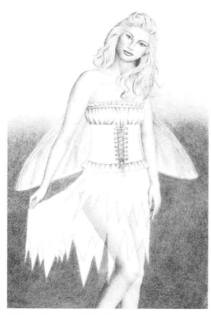

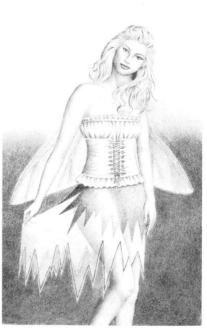

1 Sketch the Figure and Clothing
Sketch the figure lightly and loosely to establish the proportions. Erase irrelevant lines and shape the figure by carefully outlining the various subdivisions of parts—masses such as the head, the neck, the trunk and the limbs.

Next, lightly sketch and outline the clothing.

2 Develop the Hair, Face and Wings
Add lines and shading to the hair, then shade the eyes and lips. Next, shade the dark values of the figure. Outline the wings and shade the background. Detail and shade the wings.

Enhance the values in the hair by shading areas to unify the lines. Lightly shade each mass, starting with the head. Next, shade the dark and middle values of the blouse until it takes on a realistic look.

3 Shade the Clothing
Add more shading to the blouse, as the value contrast is a bit too light. Add multiple shadings to the corset to resemble wrinkles.

Lightly shade the skirt to reveal the back of the skirt, creating the illusion of translucency. Then, shade the upper part of the skirt to create a more opaque layer.

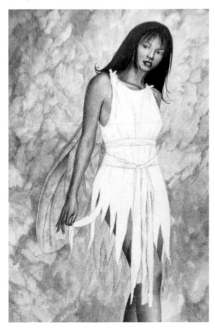

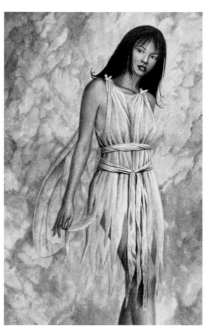

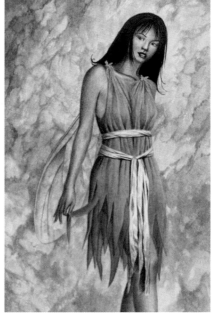

1 Draw the Clothing
Draw guidelines to show the design of the clothing.

2 Create the Underpainting
Carefully brush in a full-value underpainting with Raw Umber and small brushes. Glaze some of the dark values with Ivory Black.

3 Glaze the Dress
Layer very thin glazes of Cadmium Red Light over the Raw Umber. The thin layers allow the underpainting to show through. The red optically mixes with the umber, making the clothing appear orange.

Outline and glaze the sheer layer of clothing with Quinacridone Violet. Reduce the intensity of the violet by glazing the area with Raw Umber and then Cadmium Red Light.

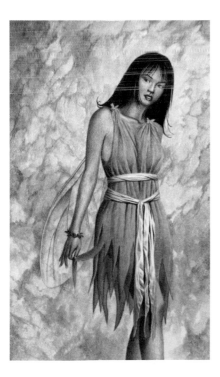

4 Glaze the Sash
Glaze the sash with Cadmium Blue Light, leaving some of the support to show through. Then, glaze the darkest values with Payne's Gray. Now, focus on the details, such as the creases. Paint sharp lines using a mix of Cadmium Blue Light and Payne's Gray. Finally, add highlights with pure Titanium White using a tiny brush.

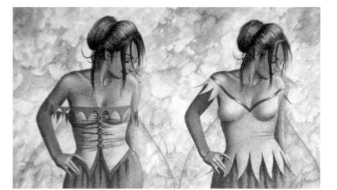

Clothing Options
Here are two different clothing designs that my fairies might wear. One is sophisticated and the other very simple.

Basic Flying Pose

Wouldn't it be wonderful to be able to fly as we do in our dreams? You must convey movement to depict a fairy in flight. The posture of the body, flow of the hair and arrangement of the limbs tell the viewer that the fairy is flying rather than levitating or hovering.

Many fantasy artists include trails of light behind a flying fairy. You can also include sparkles, glow and points of light to create an ethereal and magical appearance. Judge your design and add lighting effects as necessary to express your story. Don't overwork it!

Drawing a Flying Figure

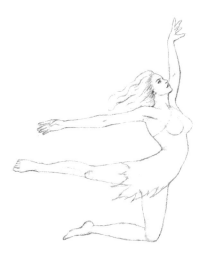

1 Establish the Proportions and the Direction of the Motion
Lightly sketch the head, torso and limbs to establish the fairy's proportions. The arc of the torso and the placement of limbs give the impression of motion. The hands and feet stretch behind the fairy, emphasizing the direction of her flight.

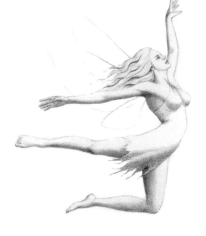

2 Begin Shading
Shade the darkest values first to establish the masses of the form. Shade in areas of the figure that are opposite the light source, which is in the upper right.

3 Add Realistic Details
Lightly shade in the middle values of the hair, face and hands to create a realistic form. Build up the value structure with shading until the gradation from dark to light is convincing. Refine the details of the clothing, then lightly shade in the middle values to create realistic forms.

Painting a Flying Figure

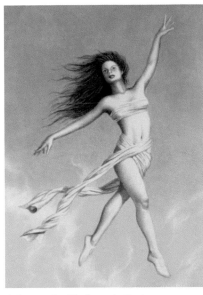

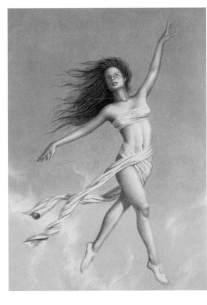

2 Develop the Skin Tone
I created the skin color with extremely diluted Cadmium Red. In fact, this simple mix is actually tinted water.

The fairy's complexion is very light, so apply very thin layers of Cadmium Red Light to achieve the desired look.

1 Create the Underpainting
This graceful flying figure is in the middle of a turn. Her hair and garment flow back, emphasizing the pattern of her flight.

After carefully drawing the fairy, glaze over the design with Raw Umber to create a full-value underpainting. Underpainting is the most time-consuming process of painting.

3 Paint the Clothing and Create Movement
Paint the garment with thin glazes of diluted Ultra marine Blue. Use four parts water to one part pigment, just enough to give the garment a warm bluish look.

Here's a trick I use to create feeling of movement: Line a very thin application of Cadmium Red along the leading edge of some of the limbs. The Cadmium Red reads as movement.

This fairy is turning to her right, so I painted a barely visible line of red along the front edge of her lower left leg and the back of her right leg. I added a line to her lower left arm as well.

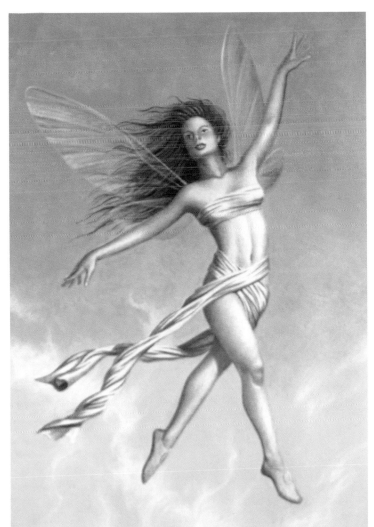

Sitting Pose

The human form is very flexible. The muscular tissue contains a large number of fibers, allowing the body to move, stand and sit with relative ease. The sitting posture is a relaxed pose, requiring very little force across the joints to support the weight of the body. The muscles of sitting fairies will appear less firm.

Drawing a Sitting Pose

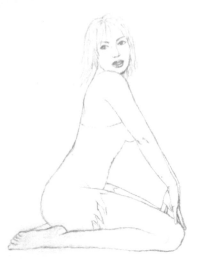

1 Draw the Outline
In this pose, most of the tension is in the back. Render the outline of the form accurately. A sitting position like the one you see here causes the back to arch. Make sure you capture this curve in your drawing.

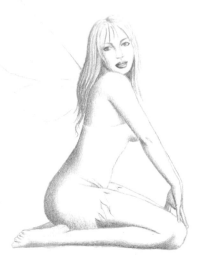

2 Begin Shading
Shade the darkest values in the areas opposite the light source (upper right). When shading a subject, I always start with the darkest areas first. It's my starting point for the midrange values.

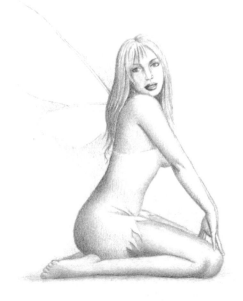

3 Add Details
Complete the hair and face details. Add lines and shading along the left side of the face and hair until you're satisfied. Then, touch up the eyes, nose and mouth to make the realism pop. Lightly shade in the middle tones across the body and limbs of the fairy to create a realistic form.

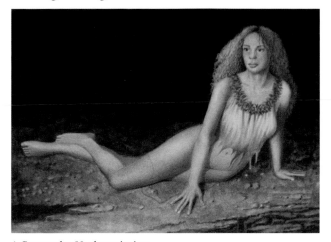

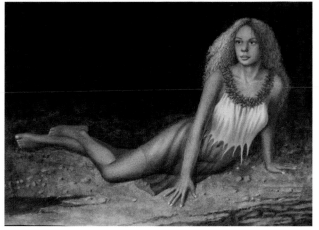

1 Create the Underpainting

This fairy's posture is more relaxed than that of the previous fairy. The area of tension is in her left arm, which is supporting much of the upper body.

Apply glazes of Raw Umber to create a full-value underpainting. Use layer after layer to build the darker values. The skin tone will show through the sheer skirt, so leave this area nude for now to develop the skin tone.

2 Develop the Skin Tone and the Skirt

Paint the skin and skirt with glazes of Raw Sienna, then apply very thin layers of Cadmium Red Light over the entire body. The complexion of this fairy is dark, so glaze the darkest values with Ultramarine Blue to liven up the skin tone.

I modified the lower half of the blouse with gesso to lighten the value.

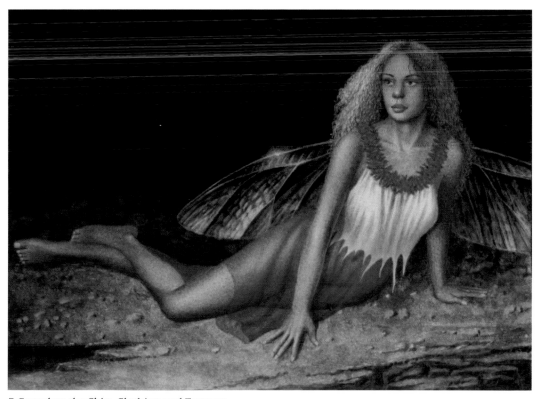

3 Complete the Skin, Clothing and Features

Thinly glaze the highlight areas with white gesso to create radiant skin. Then, glaze the clothing with Chromium Oxide Green. Finally, glaze the fairy's lips and fingernails with Cadmium Red Light.

Flowing Garments

Fairy garments often flow in the breeze or in flight. Interpreting the many folds and wrinkles can be a challenge. Remember that the beginning of the crease or fold is smaller and tighter at the starting point (normally at the waist) than it will be in the area of fabric farther down the skirt.

This fairy is wearing a dress made of heavy satin. Different fabrics behave differently when affected by wind.

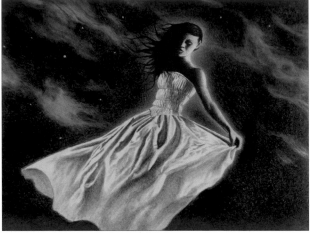

1 Apply the Underpainting
Carefully draw the design, then apply the underpainting of Raw Umber and Ivory Black. Notice how the use of light and dark in the dress creates the appearance of a satiny fabric.

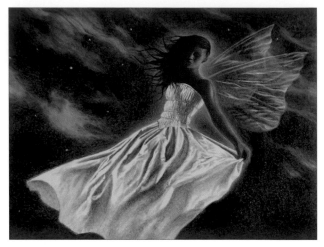

2 Paint the Skin
Paint the skin with glazes of Raw Sienna and Cadmium Red Light. The rich value contrast between the deep warmth of the fairy's skin and the strong darks and lights of the garment interprets as intense lighting. The fairy stands out dramatically from the cool background.

3 Paint the Dress
To paint the dress, apply a very thin glaze of Ultramarine Blue over all the dark values. Several layers are necessary in some areas. Next, glaze a very diluted mixture of Ultramarine Blue and Dioxazine Purple over the entire shadow side of the dress. The result appears as white.

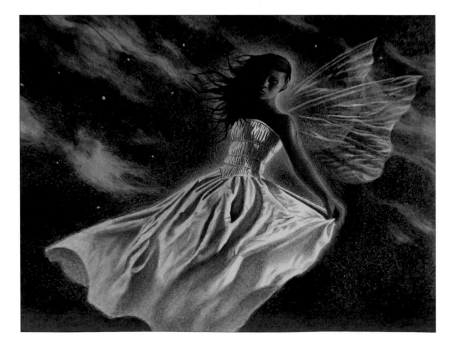

Sparkles, Light and Magical Effects

In the world of fairies, light plays a big role in interpreting special effects. Here are a few basic light effects that you can use to embellish your fairy paintings. Each starts with a foundation of white gesso underpainting. All these effects can be lightly glazed with any color you wish.

Crosslike Sparkles
Simply cross two lines that fade out from the center. Then, dab a spot of white at the center.

Starlike Sparkles
These sparkles are often seen within the aura of a fairy. Paint four crossing lines that fade out from the center. Encircle the lines with a halo to give them more prominence.

Spheres of Light
Starting in the center and working outward, scumble gesso on the support. Dilute the gesso and dab the loaded brush on a paper towel to remove most of the gesso. Gently add layers of glaze to create an evenly fading sphere.

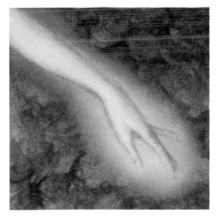

Glow
Apply very thin glazes of gesso to create a glowing effect. I applied many layers around the hand and then up the arm. I then introduced a glaze of Ultramarine Blue to draw attention to the hand and add interest.

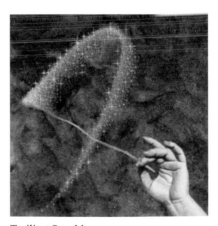

Trailing Sparkles
Trailing sparkles are most often associated with a fairy in flight. Scumble gesso thinly in an arch, starting from the tip of the wand. Then, stipple the arch with dots of gesso. Add crosses and stars next. Enhance the effect with glazes of Cadmium Yellow Medium, Yellow Oxide and Cadmium Red Light.

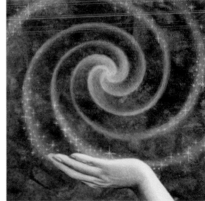

Swirl
Swirling light and sparkles can be placed at the tip of a wand or added to a spot where spiral movement is needed. Create this effect as you would a trail of sparkles, except in a spiral pattern.

Curious Fairy

Our fairy friends are inquisitive folks. Their curiosity about their natural environment enhances their magical qualities.

This little fairy loves the lusciousness of spring and summer. She wishes to reverse the change of season, so she merely touches a single leaf on a birch tree and transforms the entire forest back into the green she so adored.

MATERIALS

Surface
illustration board, toned with white gesso and Raw Umber

Brushes
nos. 2, 4, 6, 10 rounds
nos. 0, 1 liners

Pigments
Burnt Umber, Cadmium Red Light, Cadmium Yellow Medium, Chromium Oxide Green, Payne's Gray, Quinacridone Violet, Raw Umber, Titanium White, Ultramarine Blue, Vivid Lime Green, Yellow Oxide

Other Supplies
pencil, white gesso

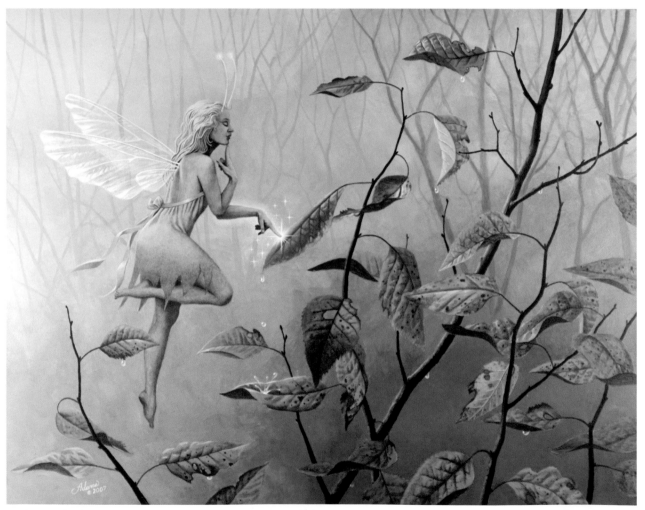

Background Advice
Build the background first, then focus on the fairy figure. To create the soft, hazy background, start with an underpainting of Raw Umber mixed with white gesso. The toned background brings a bit of warmth to the overlaid glazes.

A Magical Touch
Acrylic on illustration board
11" × 14" (28cm × 36cm)

1 Creating the Underpainting and Glow
Start with an underpainting of Raw Umber. Paint the glow around her left hand with white gesso. This fairy's posture should suggest curiosity.

2 Paint the Skin and Hair
Apply thin glazes of Cadmium Red Light to create the skin tone. Glaze the hair with Yellow Oxide and add highlights with white gesso.

3 Paint the Ribbon, Wings and Antennae
Paint the ribbon with glazes of Quinacridone Violet, then add highlights with Titanium White. Paint the sparkles around her hand with white gesso. Outline and glaze the wings with white gesso, then apply a light glaze of Vivid Lime Green. Do the same for the antennae.

Leave the garment underpainting as is; the color of the underpainting works well with the overall color scheme of the painting.

Glazing Tip

In my experience, glazing over gesso produces a more even coverage than glazing over a white pigment.

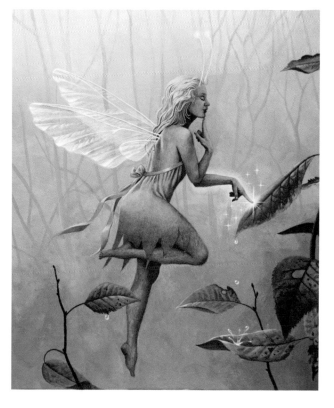

demonstration

Baby Fairy

The inspiration for this painting came as I watched an infant in a restaurant moving her hands about as if performing magic. She seemed so eager to understand this new world she's living in. The graceful movements of her arms and hands stuck in my mind.

The baby fairy in this painting is using her wand to levitate a quartz crystal. The positioning of the arms conveys the message that she is performing fairy magic.

MATERIALS

Surface
Masonite, toned with white gesso and Raw Umber

Brushes
nos. 3, 4, 6, 8, 10 rounds
nos. 12/0, 0, 1, 2 liners

Pigments
Brilliant Blue, Burnt Sienna, Burnt Umber, Cadmium Red Light, Cadmium Yellow Light, Cadmium Yellow Medium, Chromium Oxide Green, Payne's Gray, Raw Umber, Titanium White, Ultramarine Blue, Vivid Lime Green, Yellow Oxide

Other Supplies
masking fluid, pencil, sea sponge, toothbrush, white gesso

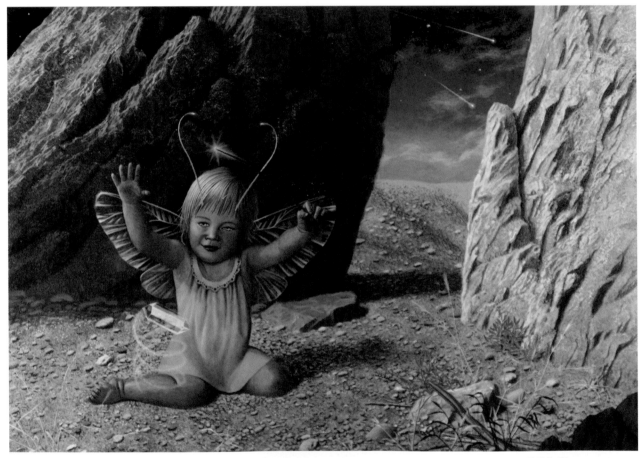

Applying Glazes
Apply masking fluid (frisket) over the fairy drawing before painting the background so that you can apply layers of glazing without worrying about losing the outlined image of the fairy. Paint the sky first with Payne's Gray at the top, fading out halfway down. Then, apply multiple glazes of Ultramarine Blue at the top half of the sky and Brilliant Blue mixed with a touch of Titanium White over the lower half. The dramatic fading of the sky and its contrast with the arid landscape create an other worldly effect.

Child's Play
Acrylic on Masonite
11" × 14" (28cm × 36cm)

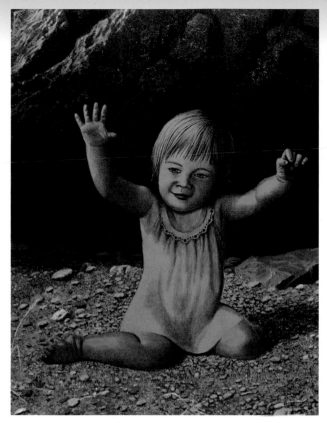

1 Create the Underpainting

Use your fingers to remove the masking fluid from the figure. Next, apply an underpainting of diluted Raw Umber. Apply very thin glazes to achieve a smoother gradation of values from light to dark. This is particularly important when painting skin. The process can be time consuming, but it's worth it.

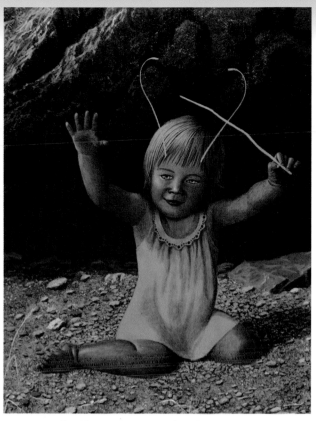

2 Paint the Skin, Hair, Wand and Antennae

Glaze many layers of Cadmium Red Light to create the skin tone. To paint the hair, apply glazes of Cadmium Red Light to the dark areas and Yellow Oxide to the middle tones. Create highlights in the hair with diluted white gesso. Paint the wand and antennae with pure, undiluted gesso.

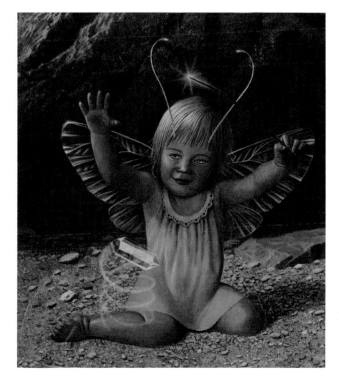

3 Develop the Clothing, Wand, Wings and Crystal

Glaze the fairy's skirt with thin layers of Ultramarine Blue. The thin glaze optically mixes with the underpainting of Raw Umber, creating the appearance of gray fabric.

Glaze the wand with Burnt Umber and Cadmium Red Light. To create the glow of the wand, apply gesso, then glaze over it with Yellow Oxide.

Paint the wing design with a mixture of Ultramarine Blue and Titanium White. Apply glazes of Titanium White or white gesso to create a shiny appearance.

Outline the crystal with thin applications of white gesso. Lay in the trails of light with gesso, stipple them with Titanium White, then apply a glaze of Yellow Oxide. The trails suggest an upward spinning movement of the crystal.

Warm Color Scheme

Warm color schemes convey a message of togetherness and strength. Red and orange are the most intense of all the colors on the color wheel. These two hues are the most often used colors when depicting sunsets.

MATERIALS

Surface
Masonite, toned with white gesso and Burnt Sienna

Brushes
nos. 3, 4, 8, 10 rounds
nos. 0, 1, 2 liners

Pigments
Burnt Sienna, Burnt Umber, Cadmium Orange Medium, Cadmium Red Medium, Cadmium Yellow Medium, Dioxazine Purple

Other Supplies
pencil, white gesso

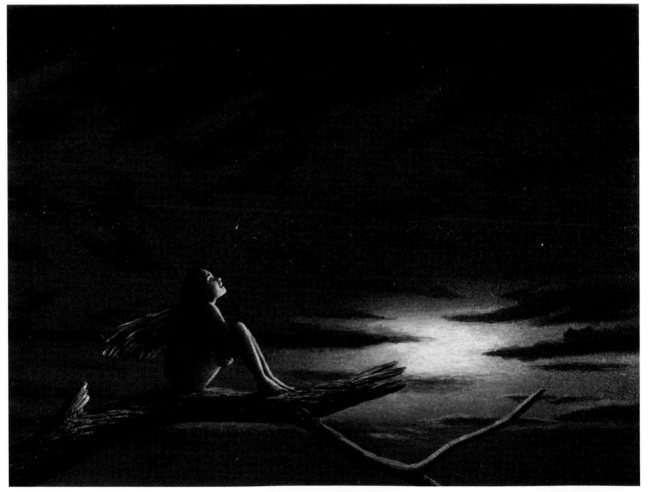

Working With a Limited Palette
This simple composition is painted with a limited palette of six colors. Before painting the figure, prime the support with gesso tinted with Burnt Sienna. Then, apply glazes of Cadmium Orange Medium to the entire surface. Glazes of Dioxazine Purple and a mixture of Dioxazine Purple and Cadmium Orange Medium establish the clouds. Finally, glaze the area of the setting sun with many layers of Cadmium Yellow Medium.

Twilight Musing
Acrylic on Masonite
8" × 10" (20cm × 25cm)

1 Apply Gesso and the Underpainting to the Fairy

Outline the subject with a pencil, then paint the fairy with the toned gesso used to prime the support. This produces a clean ground on which to draw the design. Draw with pencil and paint a full-value underpainting.

Under this lighting condition of diminished sunlight, the fairy is painted dark. Paint the fairy with glazes of Burnt Umber, leaving the highlight areas untouched.

2 Create the Branch Underpainting and Paint the Fairy's Skin

Apply an underpainting of Burnt Umber to the branch, then glaze with Cadmium Orange Medium. Paint the dark areas with Dioxazine Purple and the highlights with Cadmium Yellow Medium.

To create the fairy's skin tone, glaze over the underpainting with Cadmium Red Medium. Glaze the dark values with Dioxazine Purple. Glaze all the highlights with Cadmium Yellow Medium (the same color used on the setting sun).

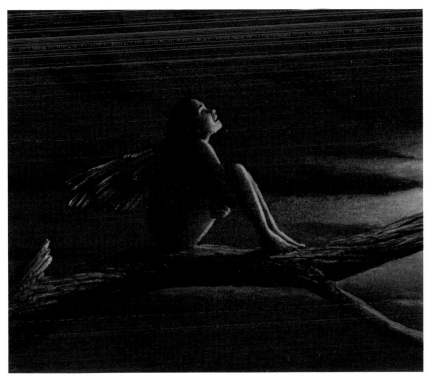

3 Paint the Wings

Outline and detail the wings with Burnt Umber. Paint highlights with white gesso, then glaze with Cadmium Yellow Medium.

The Power of Red

Red and orange have a strong impact on the human senses. Gallery owners often set up window displays of paintings with red color schemes. They know that the strong hue will attract more people to their business. Similarly, artists will sometimes place paintings with warm color schemes in the forefront of their exhibitions.

demonstration

Cool Color Scheme

Cool colors are very soothing and provide a sense of calm and feelings of trust. Blue is the most peaceful color, and cool violets create a sense of romance.

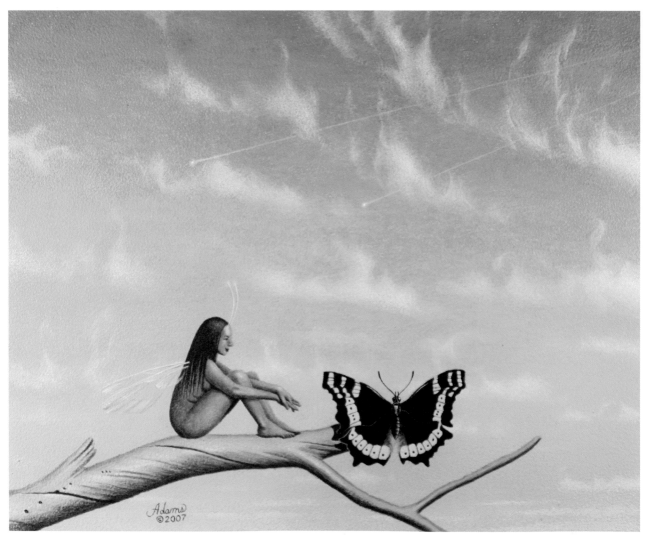

Unifying With Color
As with warm color schemes, each cool arrangement has a predominant uniting color. Prime the support with a mix of gesso and Brilliant Blue. The main glazing color in this demonstration is Ultramarine Blue. Lay in the clouds with glazes of Titanium White. The fairy adds a bit of warmth to this cool color scheme.

Afternoon Pause
Acrylic on Masonite
8" × 10" (20cm × 25cm)

1 Apply the Ground and Underpainting
Carefully outline the subjects with a pencil. Mix white gesso with Raw Umber to use as a toned ground for the subjects. Paint the details with glazes of Raw Umber to create a full-value underpainting.

2 Paint the Branch, Skin and Hair
Glaze the middle and dark values of the branch with Ultramarine Blue. Paint the highlight with Titanium White. Glaze the fairy's skin with Cadmium Red Light, then add highlights with touches of Titanium White. Use Ultramarine Blue to glaze the dark areas of the fairy's skin and hair.

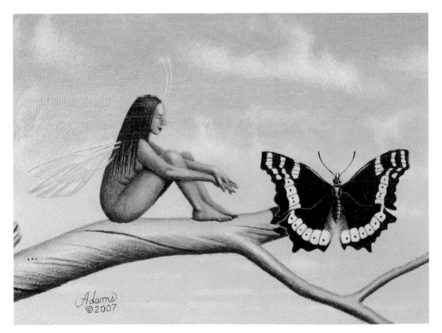

3 Paint the Fairy Wings and Butterfly
Outline and detail the fairy's wings with Ultramarine Blue. Give the wings a shiny appearance with a glaze of Titanium White.

The beautiful butterfly is known as Vanessa Charonia. The species of this genus are among the most attractive in North America.

Glaze a mixture of Ultramarine Blue and Payne's Gray over the wings and body. Several layers are necessary to achieve the proper value. Paint the spots with a mixture of Ultramarine Blue, Brilliant Blue and white gesso. Add a few touches of Titanium White to the body for highlights.

3

Painting Fairy Worlds

As artists, we must use our imaginations to create the realms in which the fairies reside. The fairy scenes that I depict are inspired by our natural environment. However, you can delineate a made-up world with unusual props or stylize the natural world to suit your wee people. Compose your fairy lands to accommodate your own vision of their world.

Gather plenty of photos and other images of nature as reference for your paintings. I keep a swap file of photos, sketches, magazine images and books that I refer to for depicting an environment, plant, insect or animal accurately.

Use your imagination; be as creative as you'd like. Keep additional references for when an unusual concept comes to mind. For instance, if you are painting a background of crystals, actual crystal clusters are the best reference choice.

This section will help you to merge a realistic world into an imagined world of fairies. The demonstrations are intended to be inspirational launching points for your own concepts.

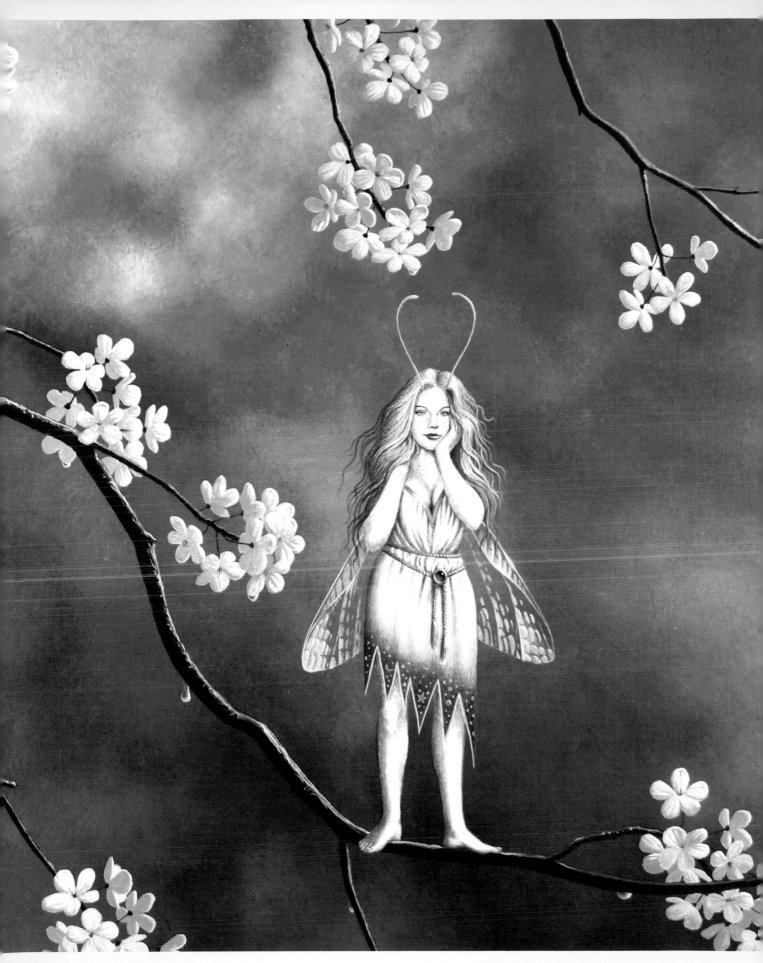

Oh Gosh! What a Beautiful Day!
Acrylic on illustration board
11" × 14" (28cm × 36cm)

Water Lilies

For this water lily painting, I decided to paint a starry night backdrop rather than a typical watery one. This gives the design a surreal appearance that tells an interesting story. The starry night sky intrigues this little fairy as she gazes in awe at the immense darkness of the universe. Her imagination wanders as she sits on her lily. She imagines herself among the stars, surrounded by them above and below.

MATERIALS

Surface
Masonite, toned with white gesso and Raw Umber

Brushes
nos. 3, 4, 6, 8 rounds
nos. 3/0, 0, 1 liners

Pigments
Brilliant Blue, Burnt Sienna, Cadmium Red Light, Cadmium Yellow Light, Chromium Oxide Green, Ivory Black, Payne's Gray, Quinacridone Violet, Raw Umber, Titanium White, Ultramarine Blue

Other Supplies
pencil, white gesso

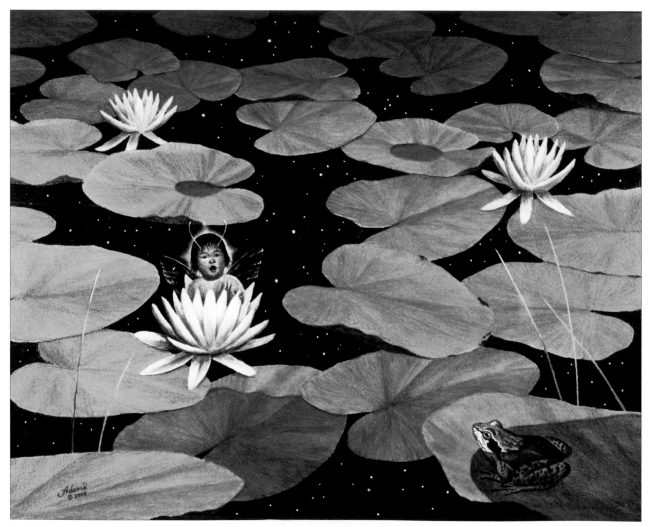

Painting a Night Sky
Draw the lily pads on the toned ground of Raw Umber mixed with white gesso. Then, carefully paint the sky with a mixture of Ivory Black and Ultramarine Blue. Spot on the stars with nos. 0 and 3/0 liners and Titanium White.

Starry Starry
Acrylic on Masonite
11" × 14" (28cm × 36cm)

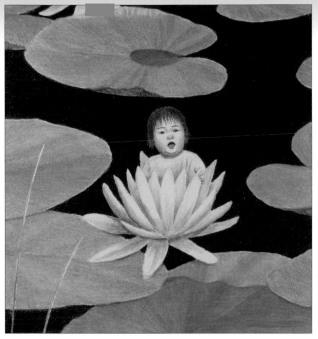

1 Apply Layers to Create the Underpainting

Glaze layers of Raw Umber over all the objects to create a full value underpainting. Some areas of the design have a single coat of paint, while others have six to eight glazed layers.

2 Develop the Lilies

Glaze all the lily pads with Chromium Oxide Green. Add the light values with a glaze of Chromium Oxide Green and white gesso. To enhance the rippled appearance of the pads, apply thin glazes of Ultramarine Blue for the dark values. The areas of the pads that are partially under water require two or three glazed layers.

3 Complete the Lilies and Fairy

Glaze the water lilies with Titanium White, then paint the baby's face and hands with glazes of Cadmium Red Light. Glaze her hair with Payne's Gray. Underpaint the wings with lines of white gesso, then glaze the wings with Ultramarine Blue. Touch up the painting here and there to bring out some of the highlights on the lily pads.

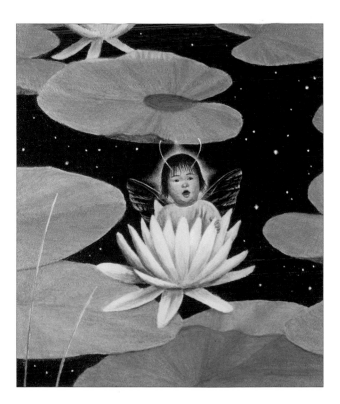

Wildflowers

The wildflowers in this painting are called foxglove or *Digitalis purpurea*. Foxglove is also known as fairy fingers, fairy bells, fairy thimbles and fairy cap, and it is one of my favorite flowers. These flowering stalks grow to 3 to 4 feet (1 to 1.2m) with tubular flowers that are up to 2 inches (5cm) long. They vary in color from white to lavender to purple and are abundant throughout Europe and the Americas.

These beautiful flowers can be challenging to paint and time consuming to delineate, so be patient. I drew the design on the support, and carefully scumbled the background to create a blurry appearance.

MATERIALS

Surface
Masonite, toned with white gesso and Raw Umber

Brushes
nos. 3, 4, 8, 10 rounds
nos. 3/0, 0, 1, 2 liners

Pigments
Burnt Sienna, Cadmium Red Light, Cadmium Red Medium, Cadmium Yellow Light, Chromium Oxide Green, Dioxazine Purple, Payne's Gray, Quinacridone Violet, Raw Umber, Titanium White, Ultramarine Blue, Vivid Lime Green, Yellow Oxide

Other Supplies
pencil, white gesso

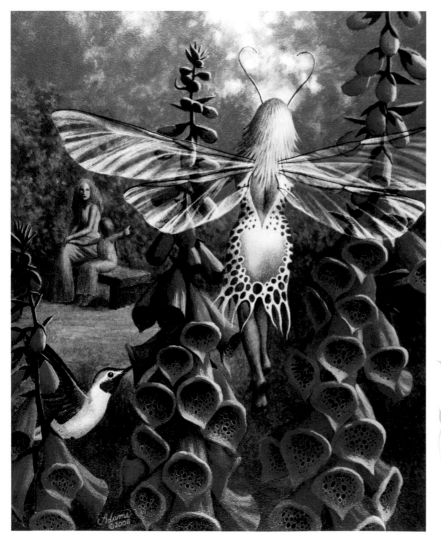

Background Story
The vivid imaginations of children often lead to playful make-believe. Their innocence sometimes opens their vision to the elementals of the natural world. Here, a mother and her daughter sit on a park bench, and the child is suddenly filled with excitement as she spots a fairy among some flowers. The mother looks over at the flowering stalks and tells the girl, "No, dear, that's a hummingbird."

No, Dear, That's a Hummingbird
Acrylic on Masonite
14" × 11" (36cm × 28cm)

Focusing Attention
The contrast between a detailed, focused foreground and a blurry background gives a lot of strength to the center of interest. The viewer's attention will always turn to the part of a painting that stands out the most.

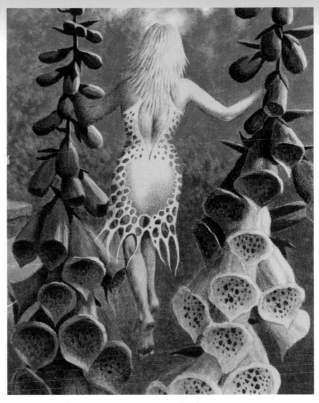

1 Create the Underpainting
Carefully underpaint the flowers, fairy and hummingbird with Raw Umber. Creating a full-value underpainting for these flowers is a time-consuming process. Work from top to bottom, starting with the flowering stalk on the far left.

2 Paint the Stems, Leaves and Blossoms
Paint the stems and leaves of the flowers with glazes of Chromium Oxide Green mixed with Payne's Gray. Use a mixture of Vivid Lime Green and Chromium Oxide Green for the light areas.

Apply Dioxazine Purple to the blossoms. Then, use a Dioxazine Purple and Titanium White mixture to glaze the light values.

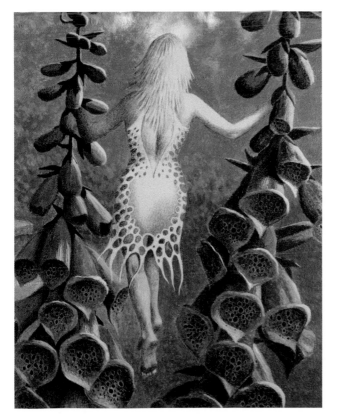

3 Complete the Blossoms
Enhance the dark values of the blossoms with glazes of Ultramarine Blue. Lightly glaze the inside of a few blossoms with Quinacridone Violet, giving the flower a feeling of warmth.

The final step brings the flowers to life. Use an undiluted (no water added) mixture of Ultramarine Blue and Payne's Gray to create the blossoms' spots. Then circle the spots with the Dioxazine Purple/Titanium White mixture from step 2.

Deciduous Trees

A deciduous tree or shrub has leaves that drop every year during the autumn. This is the survival mode that the tree uses to withstand the cold or dryness. In this painting, an enchanting and lovely woman of the forest befriends a tiny fairy. She is elated that a fairy trusts her enough to set foot on her finger.

MATERIALS

Surface
Masonite, toned with white gesso and Raw Umber

Brushes
nos. 3, 4, 6, 8 rounds
nos. 18/0, 0, 1, 2 liners

Pigments
Burnt Sienna, Burnt Umber, Cadmium Red Light, Chromium Oxide Green, Emerald Green, Light Blue Permanent, Payne's Gray, Raw Umber, Titanium White, Ultramarine Blue, Vivid Lime Green, Yellow Oxide

Other Supplies
pencil, white gesso

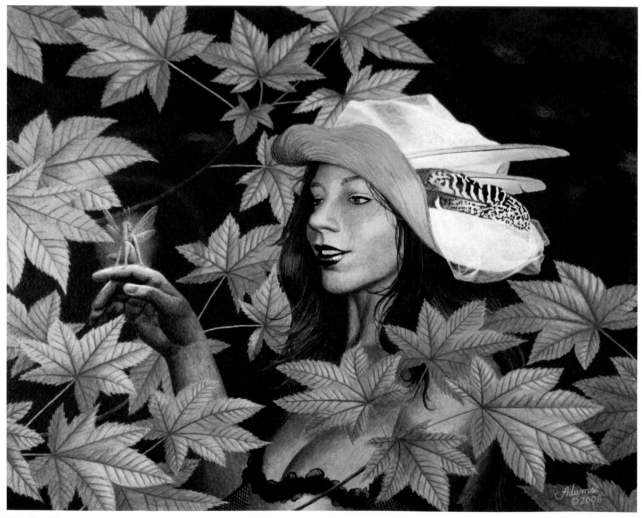

Detailing Leaves
I chose to paint a close-up view of a small portion of the tree rather than the whole tree. This allowed me to demonstrate the detailing of groups of leaves rather than a mass of leaves on a distant tree. I used reference photos of a tree known as vine maple. I stylized the leaves to delineate them larger and more pointed than they actually are.

New Found Friend
Acrylic on Masonite
8" × 10" (20cm × 25cm)

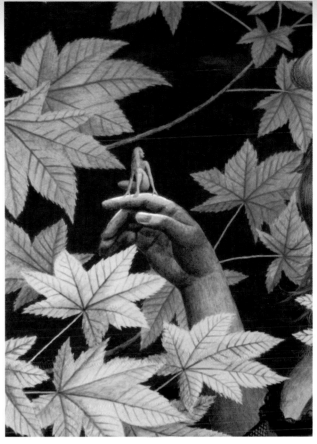

1 Create the Underpainting
While painting the background, many of the leaves may take on some of the background color. This isn't a problem. Restore the shapes of the stems and leaves with two to three layers of white gesso. Add the jagged edges of the leaves. Then, underpaint all the leaves with Raw Umber.

2 Develop the Leaves
Glaze each leaf with one to four layers of Chromium Oxide Green. Thinly glaze layers of Vivid Lime Green and Yellow Oxide onto some of the front leaves to show a slight variation in color.

3 Finish the Leaves
Thinly glaze many of the leaves with a mixture of Ultramarine Blue and Titanium White. This creates a more realistic look. To finish the painting, complete the fairy and touch up the woman.

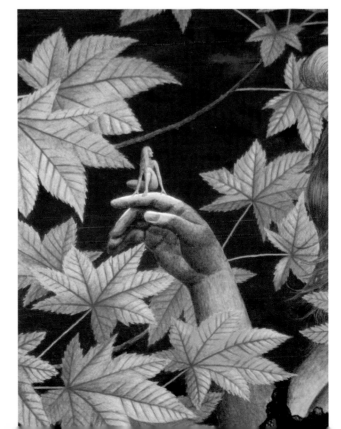

demonstration

Evergreen Trees

An evergreen tree keeps its leaves throughout the year rather than losing them during the cold season. The evergreens of northern continents are mostly conifers (cone-bearing trees) with needlelike leaves.

MATERIALS

Surface
illustration board, toned with white gesso and Payne's Gray

Brushes
nos. 3, 6, 8, 10 rounds
nos. 0, 1 liners

Pigments
Burnt Sienna, Burnt Umber, Cadmium Red Light, Cadmium Yellow Light, Cadmium Yellow Medium, Chromium Oxide Green, Payne's Gray, Raw Umber, Titanium White, Ultramarine Blue, Vivid Lime Green, Yellow Oxide

Other Supplies
pencil, white gesso

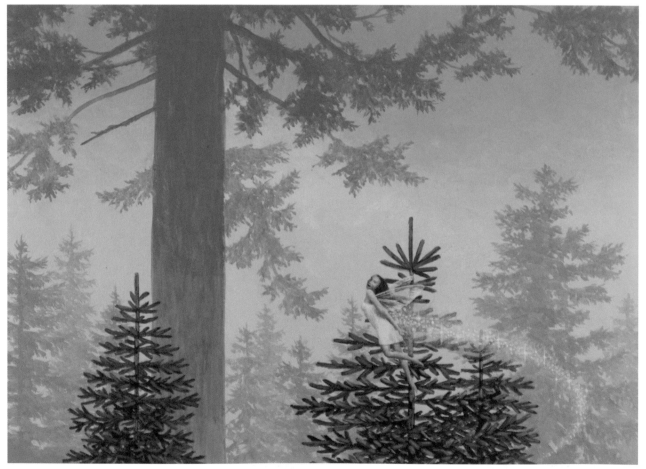

Creating Distance
To create this wintry scene, prime the support with white gesso mixed with Payne's Gray. Then, starting at the bottom, wash on white gesso, letting it fade out as you work toward the top. Then sketch and paint the trees with a mixture of Payne's Gray and Chromium Oxide Green. A thin glaze of diluted white gesso pushes most of the trees into the distance.

Misty Forest Flight
Acrylic on illustration board
8" × 10" (20cm × 25cm)

1 Underpaint the Trees

Underpaint the foreground trees dark with a mixture of Chromium Oxide Green and Payne's Gray.

2 Develop the Tree's Foundation

Next, paint the trunk of the tree with white gesso and the green needles with a mixture of Chromium Oxide Green and white gesso. This creates the foundation for subsequent layers of glazing.

3 Layer Additional Glazes

Glaze the trunk with Raw Umber and Cadmium Red Light. Then, glaze the rest of the tree with Vivid Lime Green.

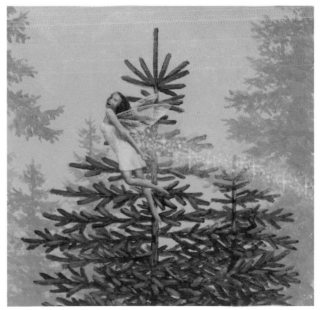

4 Finish the Tree

Glaze all the foreground trees with Ultramarine Blue to cool and unify the colors. Paint the fairy at the very end.

demonstration

Grass

Shown here is a lovely fairy playing her woodland harp on a grassy hill. Grass is a very thin plant that easily bends with the slightest breeze. In this painting, the grass blades are dancing in unison and bending to the right, suggesting that a bit of wind is in the air.

Painting a field of grass can be a tedious proposition for the beginning painter. In four easy steps, this demo will show you how to paint grass with ease.

MATERIALS

Surface
illustration board, toned with white gesso and Raw Umber

Brushes
nos. 4, 6, 10 rounds
nos. 18/0, 0, 2 liners
no. 1 detail

Pigments
Burnt Sienna, Burnt Umber, Cadmium Orange Medium, Cadmium Red Light, Cadmium Yellow Medium, Chromium Oxide Green, Light Blue Permanent, Payne's Gray, Quinacridone Violet, Raw Umber, Titanium White, Ultramarine Blue, Vivid Lime Green

Other Supplies
pencil, white gesso

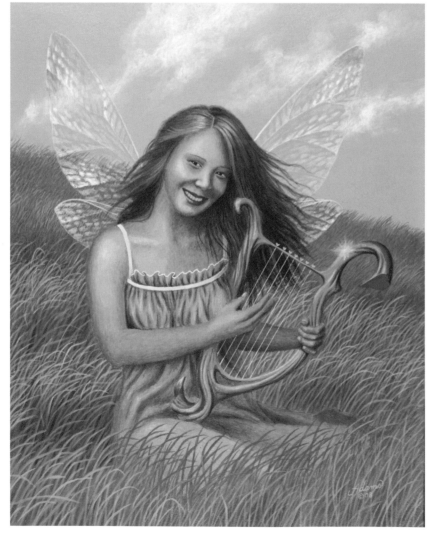

Magical Sounds
This smiling fairy loves to play her woodland harp while sitting in a grassy field. Her stringed instrument is not an ordinary one. It's magical too, and its sound is felt by nature. The surrounding plants react to the melody by creating a light show akin to an aurora borealis.

Grassland Harpist
Acrylic on illustration board
10" × 8" (25cm × 20cm)

1 Begin Painting the Grass

Apply streaky strokes of Chromium Oxide Green, Ultramarine Blue, Payne's Gray and Titanium White to emulate the growth direction of the grass. Apply the paint loosely and thinly. Painting the brushstrokes at an angle to the right makes the grass appear as if there's a breeze.

2 Block In the Dark and Light Values

Block in the dark values with Ultramarine Blue and the light values with Vivid Lime Green, Cadmium Yellow Medium and Cadmium Orange Medium.

3 Develop the Grass

Apply transparent washes of cool and warm hues over the back- and middle ground. Then, use a no. 0 liner to create quick, angled strokes of thin, watery paint for individual blades of grass in the background. . Use a slightly larger brush to paint grass blades in the middle ground with Cadmium Yellow Medium, Vivid Lime Green, white gesso and a bit of Burnt Umber.

After you finish the background, paint the fairy. Then, brush foreground blades of Chromium Oxide Green mixed with a bit of Payne's Gray over the fairy.

4 Finish the Grass

Use the colors from step 3 to paint and glaze the blades of grass in the foreground. Then, brighten up the grass using Cadmium Yellow Medium and Cadmium Orange Medium, glazed on separately. Mix white gesso with the warm hues to add detail to some of the grass blades.

Finally, paint dark windows between some of the grass blades to develop the illusion of realism. This makes it appear as if there is more depth within the grass.

Butterfly

This fairy is relaxed in a comfortable nook in the forest. She smiles with delight as a swallowtail butterfly lands to rest in front of her.

This swallowtail painting is based on a detailed drawing I did a few years ago. For the drawing, I worked from an actual specimen, a resource I commonly use when painting or drawing insects.

MATERIALS

Surface
illustration board, toned with white gesso and Raw Umber

Brushes
nos. 3, 4, 6 rounds
nos. 0, 2 liners
no. 1 detail

Pigments
Burnt Sienna, Burnt Umber, Cadmium Red Light, Cadmium Red Medium, Cadmium Yellow Light, Cadmium Yellow Medium, Chromium Oxide Green, Light Blue Permanent, Payne's Gray, Quinacridone Violet, Raw Umber, Titanium White, Ultramarine Blue, Vivid Lime Green

Other Supplies
masking fluid, pencil, sea sponge, white gesso

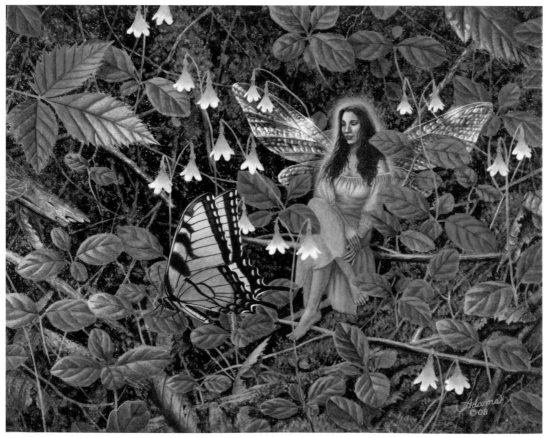

Creating a Complicated Background
A background like this is a bit time-consuming, even for a small painting. After drawing the composition, protect the butterfly, the fairy and some of the leaves and debris with masking fluid. Then, apply layers and layers of glazing, stippling and sponging to develop the moss, leaves, bark and flowers.

Leafy Nook
Acrylic on illustration board
8" × 10" (20cm × 25cm)

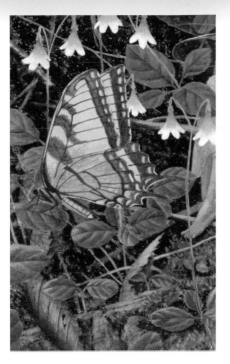

1 Apply the Underpainting
After you remove the masking fluid, apply diluted Raw Umber to create the underpainting of the butterfly. Use a small liner brush to carefully delineate every detail of the butterfly. Use a no. 1 detail brush for the spots and dark areas.

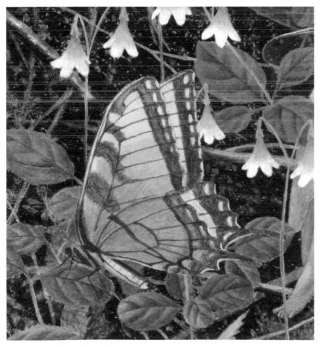

2 Develop the Wings
Paint a line of spots with Light Blue Permanent. Paint the spots below the row of blue spots with Cadmium Yellow Medium, then glaze the orange spots with Cadmium Red Light. Glaze Cadmium Yellow Light over both wings. Follow with a glaze of Cadmium Red Medium over the bottom wing and over part of the larger wing, giving these areas a slightly darker value.

3 Finish the Wings
Paint the black areas with a mixture of Payne's Gray and Raw Umber. Finally, line the trailing edge of the wings with Titanium White.

demonstration

Birds

I love to paint birds, but, in order to accurately depict our fine feathered friends, you need a little knowledge of birds' anatomical structure. The feathers of all birds are grouped and arranged in the same manner, with primary, secondary and tertiary feathers, so a basic understanding of this arrangement and layering will allow you to render any bird convincingly.

MATERIALS

Surface
illustration board, toned with white gesso and Raw Umber

Brushes
nos. 3, 4, 8, 10 rounds
nos. 12/0, 0, 1 liners

Pigments
Burnt Sienna, Burnt Umber, Cadmium Red Light, Cadmium Red Medium, Cadmium Yellow Light, Cadmium Yellow Medium, Chromium Oxide Green, Payne's Gray, Quinacridone Violet, Raw Umber, Titanium White, Ultramarine Blue, Vivid Lime Green, Yellow Oxide

Other Supplies
masking fluid, pencil, white gesso

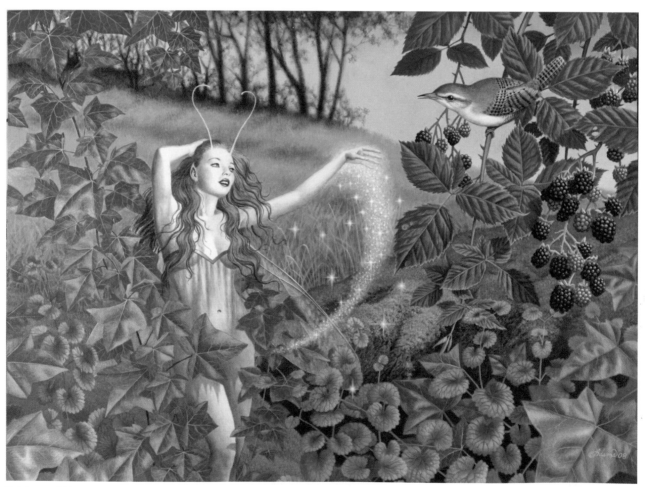

Fairies and Nature
This lovely fairy is interacting with a small wren. The bird is amused and mesmerized by the fairy and her magic. Fairies have a unique kinship with the animal kingdom. They have a mutual adoration and respect for nature and are often at play within forests and fields.

Feathered Friend
Acrylic on illustration board
12" × 16" (30cm × 41cm)

1 Draw the Wren

Draw the wren carefully down to the smallest detail. At this point, cover the bird with a masking fluid so that you can paint the background.

2 Create the Underpainting

Establish the underpainting with glazes of Raw Umber. This is simply a matter of glazing over the detailed drawing. The spots and the dark areas will require three to four applications. Glaze the rest lightly.

3 Paint the Eye, Feathers, Beak and Spots

Paint the bird's eye with Burnt Sienna. Apply layers of Burnt Umber to the feathers. Apply a touch of Cadmium Red Light to the lower beak. Brighten the white areas of the body with Titanium White. To finish, paint the spots with a mixture of Payne's Gray and Burnt Umber.

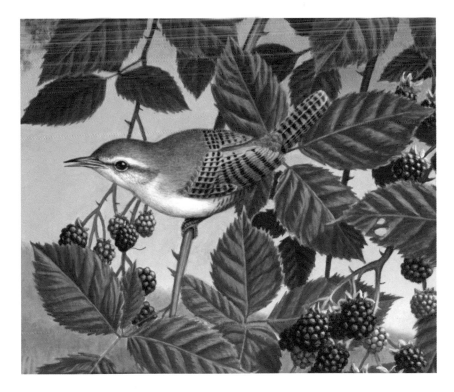

Reflections

To portray water reflections convincingly, think of the surface as an undulating mirror. A body of water can be calm and still or filled with movement. The environment, particularly wind, will determine the evenness of the water's surface.

In this demonstration, I chose to depict water that's relatively calm with slight disturbances. I wanted to show how reflections scatter and stretch.

MATERIALS

Surface
illustration board, toned with white gesso and Burnt Sienna

Brushes
nos. 2, 3 rounds
nos. 0, 1 liners

Pigments
Burnt Sienna, Cadmium Red Light, Chromium Oxide Green, Payne's Gray, Quinacridone Violet, Raw Umber, Titanium White, Ultramarine Blue, Vivid Lime Green

Other Supplies
pencil, white gesso

Water Dance
Acrylic on illustration board
7" × 14" (18cm × 36cm)

Background Considerations
For this painting I envisioned the fairy skimming across the water in a graceful manner. I wanted to portray a simple design with very little detail, and I decided that a wide format would work best. Prime the support with a mixture of white gesso and Burnt Sienna, which is the dominant color in the finished piece.

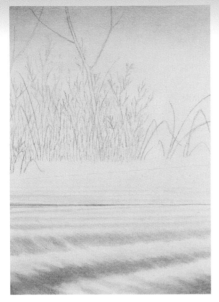

1 Glaze the Water
After drawing the design on the support, glaze the water with layers of Payne's Gray, creating the impression of slight swells.

2 Glaze the Foliage
Glaze the foliage with Raw Umber to establish the underpainting. To prepare the blades of grass and leafless stems for glazes, apply the gesso mixture you used to prime the support.

3 Develop the Foliage
Glaze the foliage with Chromium Oxide Green, followed by Vivid Lime Green for the light areas. Glaze Ultramarine Blue over most of the forefront vegetation to separate it from the foliage behind it. The blue pushes that area forward into the picture plane.

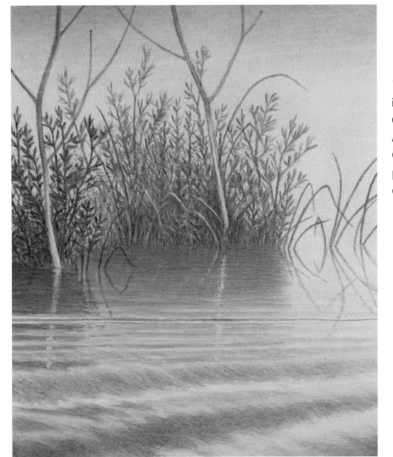

4 Paint the Reflections
Paint the reflections of all the grasses in the water with glazes of Raw Umber. Carefully paint all the angles in reverse. After completing the reflections, glaze Chromium Oxide Green over the underpainting. Then, glaze Ultramarine Blue over the dark areas.

demonstration

Mushrooms

The most commonly painted mushroom among fairy artists is the *Amanita muscaria*, which has red tops with white spots. I wanted to paint something a little different in this painting, so I chose the Sulfur Tuft. These mushrooms are extremely common, and they grow in huge groups around dead trees and fallen branches. Mushrooms have a simple, easy-to-paint structure. It's basically a cap and a stem.

MATERIALS

Surface
Masonite, toned with white gesso and Raw Umber

Brushes
nos. 2, 3, 6, 8 rounds
nos. 12/0, 3/0, 0, 1 liners

Pigments
Burnt Sienna, Burnt Umber, Cadmium Red Light, Cadmium Yellow Light, Chromium Oxide Green, Quinacridone Violet, Raw Umber, Titanium White, Ultramarine Blue, Vivid Lime Green, Yellow Oxide

Other Supplies
masking fluid, pencil, sea sponge, white gesso

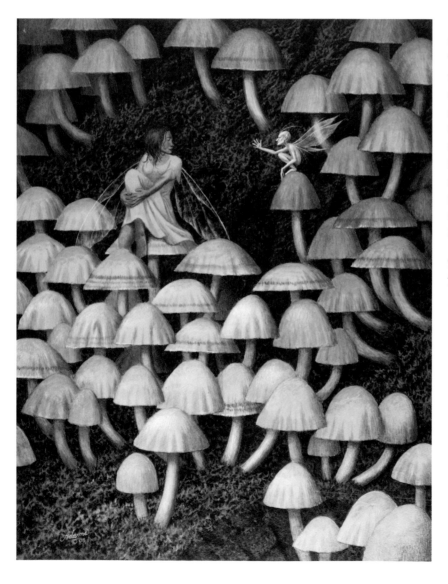

Creating a Background
To create the background, wash a dark mixture of Ultramarine Blue and Burnt Umber over the entire surface (mask the mushrooms with masking fluid to protect them). Use a sea sponge to smear Chromium Oxide Green in random spots over the dark background to create moss. Then, glaze the moss with Burnt Sienna and Yellow Oxide. Finally, use a liner brush to apply Vivid Lime Green, Yellow Oxide and Cadmium Yellow Light to bring out the details of the moss.

The Storyteller
Acrylic on Masonite
14" × 11" (36cm × 28cm)

1 Remove the Masking Fluid
After completing the background, remove the masking fluid with your fingers. The preserved shapes are now ready for the underpainting.

2 Create the Underpainting
Apply the underpainting with glazes of Raw Umber. Apply thin glazes along the bottom of the mushroom caps to give the appearance of ripples. The light source is in the front/left, so the right side of the stems should be darker.

3 Develop the Mushrooms
Paint the light values with glazes of white gesso. Glaze some of the tops of the mushroom caps with Yellow Oxide (just a slight hint to give them a sulfur look). Very lightly glaze some of the mushrooms with white gesso to enhance the ripples. Then, line the bottom edges of some of the caps with white gesso and a no. 0 liner.

When painting a grouping, such as these mushrooms, it's not always necessary to fully detail every object. Too much detail may distract from the center of interest.

demonstration

Waterfall

Painting a waterfall is just as exciting as viewing one in the wilderness. In this demonstration I concentrated on showing what happens to the water behind the waterfall.

MATERIALS

Surface
illustration board, toned with white gesso and Burnt Sienna

Brushes
nos. 2, 4, 6, 8, 10 rounds
nos. 0, 1 liners

Pigments
Burnt Sienna, Burnt Umber, Cadmium Red Light, Cadmium Yellow Light, Cadmium Yellow Medium, Chromium Oxide Green, Emerald Green, Payne's Gray, Quinacridone Violet, Raw Umber, Titanium White, Ultramarine Blue, Vivid Lime Green

Other Supplies
pencil, white gesso

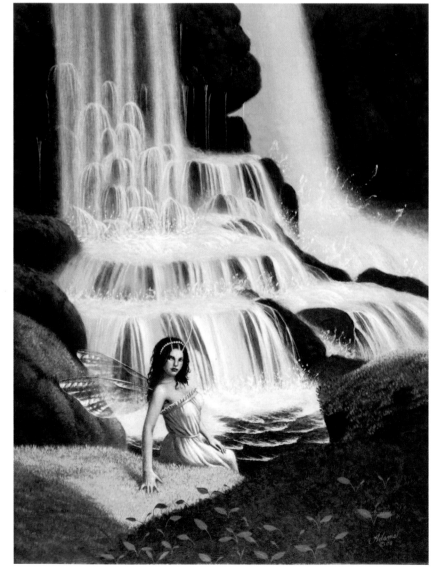

Creating Drama
This fairy has made some time to just relax at the bottom of a beautiful gorge. She looks behind her as she waits for her partner to arrive. Fairies appreciate and adore the beauty of nature.

I wanted to create a dramatic depiction of a spotlit fairy in front of a strong, warm waterfall. The warmth of the support shows through the design, giving warmth to the scene.

A Day at the Falls
Acrylic on illustration board
12" × 9" (30cm × 23cm)

1 Draw the Composition and Apply the Underpainting

Mix some Burnt Sienna with white gesso to prime the support. This warmth will affect and show through the subsequent layers of colors. Glaze several layers of Raw Umber to create the underpainting.

2 Develop the Rocks and Water

Paint the rocks next. To darken and solidify the rocky areas, apply a mixture of Burnt Umber and Ultramarine Blue. Then, paint the streams of water with white gesso. Thinly glaze Ultramarine Blue over most of the water. This will serve as a basecoat for subsequent layers of paint.

3 Finish the Waterfall

Use white gesso to add more details. Glaze diluted white gesso over the rocks in streams to resemble falling water. Mix a bit of Ultramarine Blue with white gesso, and glaze the mixture over the waterfall. To develop the realism, apply a thin glaze of Titanium White over all the blue areas. Thinly glaze diluted white gesso along the edges of all the falling water. Use undiluted Titanium White to highlight the water pouring over the rocks to bring out the details and to show the play of direct light on the scene.

demonstration

Clouds

In this painting, I wanted to depict a fairy with a dreamy posture drifting among the clouds. I positioned the fairy a bit to the left of the focal point in order to give the viewer a greater sense of forward movement. Only three basic colors are necessary to achieve these realistic clouds.

MATERIALS

Surface
illustration board, primed with white gesso

Brushes
nos. 2, 4, 6, 8, 10 rounds
nos. 3/0, 0, 1 liners

Pigments
Burnt Umber, Cadmium Red Light, Dioxazine Purple, Light Blue Permanent, Raw Umber, Ultramarine Blue, Yellow Oxide

Other Supplies
pencil, white gesso

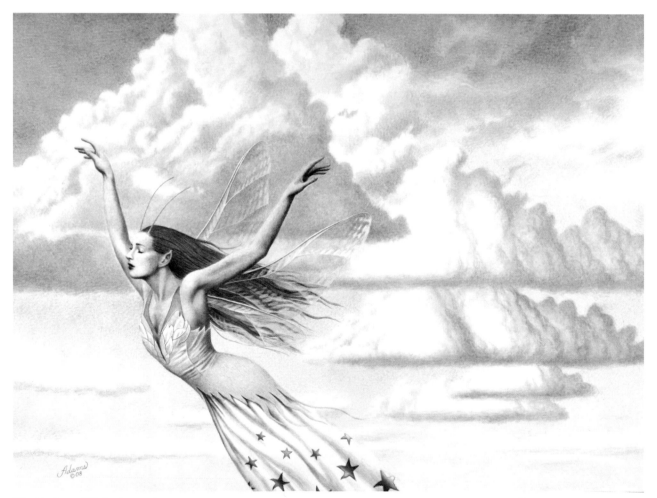

Working on a White Support
I chose a white support (primed with white gesso) for this painting so that I wouldn't have to apply a white hue for the highlights. The white ground will show through in the finished piece, creating the highlights.

Dreamscape
Acrylic on illustration board
9" × 12" (23cm × 30cm)

1 Sketch the Clouds and Develop the Sky

Lightly sketch the clouds. The outlines should be very faint so that the pencil marks do not show through in the finished piece.

Apply thin washes of Ultramarine Blue for the background sky. Starting from the top of the support, apply as many layers as necessary to achieve the values of a sky. As you move lower, apply fewer layers to create lighter values. Atmospheric effects cause the value of the sky to decrease incrementally toward the horizon line. I applied seven layers of glaze in the top portion of the sky and just one thin glaze at the midpoint.

Starting at the bottom, thinly glaze a mixture of Light Blue Permanent and a bit of white gesso. Work upwards to overlap the Ultramarine Blue application. The atmospheric perspective and overlapping clouds create depth.

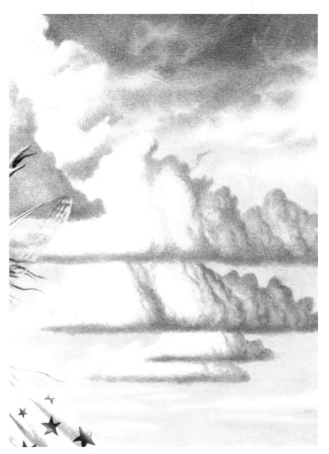

2 Underpaint the Clouds

Underpaint the clouds with Dioxazine Purple to enhance the warm dreaminess of the fairy.

Purple Skies

Dioxazine Purple is often used in clouds and skies to bring out the warmth of the sky. It's a good color choice when painting stormy skies as well.

3 Complete the Clouds

Complete the clouds with multiple glazes of Ultramarine Blue.

demonstration

Rocks

If you think depicting rocks is difficult…think again! Simply by starting with a toned ground and using a toothbrush to create texture, you'll save a lot of time when painting a rocky landscape.

MATERIALS

Surface
illustration board, toned with white gesso and Raw Umber

Brushes
 nos. 1, 2, 4, 6, 8 rounds
 nos. 00, 1 liners
 large, frayed bristle brush

Pigments
 Burnt Sienna, Burnt Umber, Cadmium Red Light, Chromium Oxide Green, Emerald Green, Payne's Gray, Raw Umber, Titanium White, Ultramarine Blue

Other Supplies
masking fluid, pencil, toothbrush, white gesso

A Curious Fairy
Fairies are attracted to sparkly, shiny things. Not knowing what the object is, this fairy is cautious as he approaches a gold ring that caught his eye while he was flying by.

The Ring
Acrylic on illustration board
9" × 12" (23cm × 30cm)

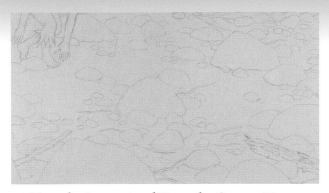

1 Tone the Support and Draw the Composition

Tone the support with a ground of Raw Umber and white gesso, then draw the composition. The toned ground is an important aspect of this design, as it serves as the basic gray midtone of the rocks.

2 Apply the Underpainting

Create a full-value underpainting with glazes of Raw Umber. Pay attention to the light source, which in this case is in the front/left, and render the cast shadows accordingly. Before proceeding to the next step, mask the fairy to protect it.

3 Develop the Texture

Rub a toothbrush into some diluted Payne's Gray. Stroke the bristles with your thumb so that the paint splatters the surface with spots. This adds texture, which makes the rocks appear more realistic.

Next, use a large, frayed bristle brush to apply diluted white gesso. Lightly dab the painting to add more texture to the ground.

With the nos. 1 and 2 rounds, add more debris and pebbles using the gesso you used to prepare the support in step 1.

4 Finish the Rocks

Glaze the rocks with Ultramarine Blue, Payne's Gray and a bit of Burnt Umber. Use these colors separately. Paint the grayish rocks with a mixture of Ultramarine Blue and white gesso. Then glaze Ultramarine Blue over the shadow areas. Glaze some of the debris with Burnt Sienna, then highlight the rocks with white gesso. Remove the masking fluid from the fairy.

Rainbow

On a showery day, one may be blessed with the appearance of a rainbow. Appearing in the sky opposite the light source, rainbows form when raindrops are struck by light at specific angles. Rainbows will also appear when viewing a waterfall, which is especially pleasing to the eye.

MATERIALS

Surface
illustration board, toned with white gesso and Raw Umber

Brushes
nos. 2, 4, 6, 10 rounds
nos. 0, 1 liners

Pigments
Brilliant Blue, Burnt Umber, Cadmium Red Light, Cadmium Yellow Light, Chromium Oxide Green, Dioxazine Purple, Payne's Gray, Raw Umber, Titanium White, Ultramarine Blue, Vivid Lime Green

Other Supplies
pencil, white gesso

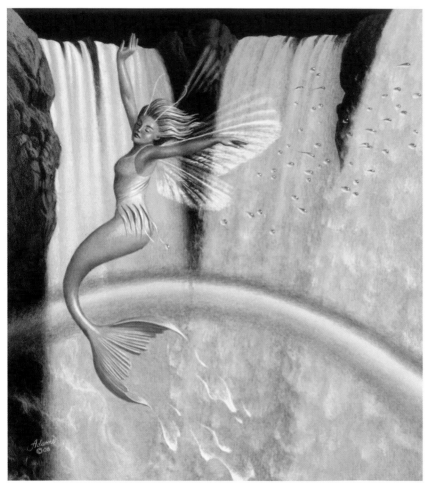

Painting Raindrops
A raindrop (or a drop from a waterfall) acts like a prism. The light enters a raindrop, splits into its separate color waves, reflects to the opposite side and then emerges from the bottom of the raindrop as a wavelength of color. As the raindrops fall, they reflect a wavelength of another color and so on. So, as countless raindrops fall, the entire spectrum of color is revealed. The larger the raindrops are, the brighter the rainbow appears.

Water Sprite
Acrylic on illustration board
10" × 9" (25cm × 23cm)

1 Paint a White Arc
Paint a scumble of white gesso in an arc. This step is an important part of achieving an iridescent look.

2 Add the Purple and Blue Arcs
Lightly glaze a passage of Dioxazine Purple across the bottom of the arc, then add a glaze of Brilliant Blue above it, overlapping the purple. Overlapping the hues creates tertiary colors, which gives your rainbows a more ethereal appearance.

3 Apply the Yellow and Red Arcs
Add a glaze of Cadmium Yellow Light, overlapping the blue. Next, add a glaze of Cadmium Red Light to complete the bow.

Rainbows can be very bold and colorful or very faint and ethereal. You can control the chroma of the colors by limiting or increasing the glaze layers.

4
Painting the Big Picture

From concept to completion, the process of painting is always exciting. Each painting presents new challenges. It's always a good idea to create thumbnail sketches to work out the composition. If necessary, create a detailed preliminary drawing of your idea, or paint a detailed study with focus on the center of interest.

The more complex your concept is, the more renderings you will have to do. You must have a clear mental image of the finished painting. Sketching the idea clarifies that image. If your concept is simple, it may not be necessary to complete all these preliminary steps. A few thumbnails will suffice.

In this section, I will lay out my painting procedure in more detail. Here you'll find additional information as well as close-up images of the paintings.

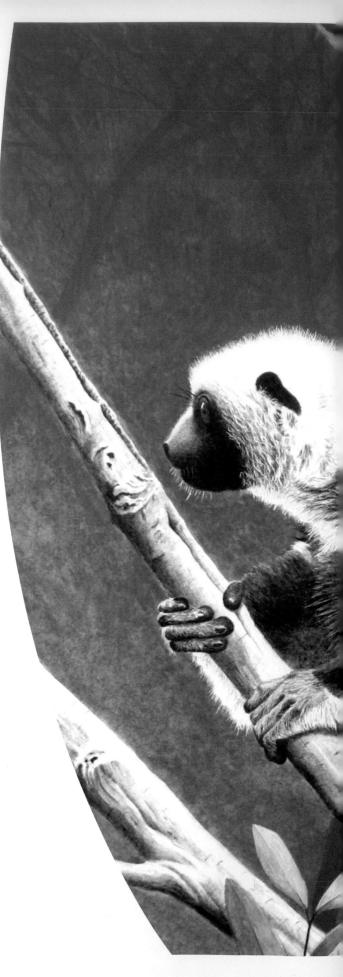

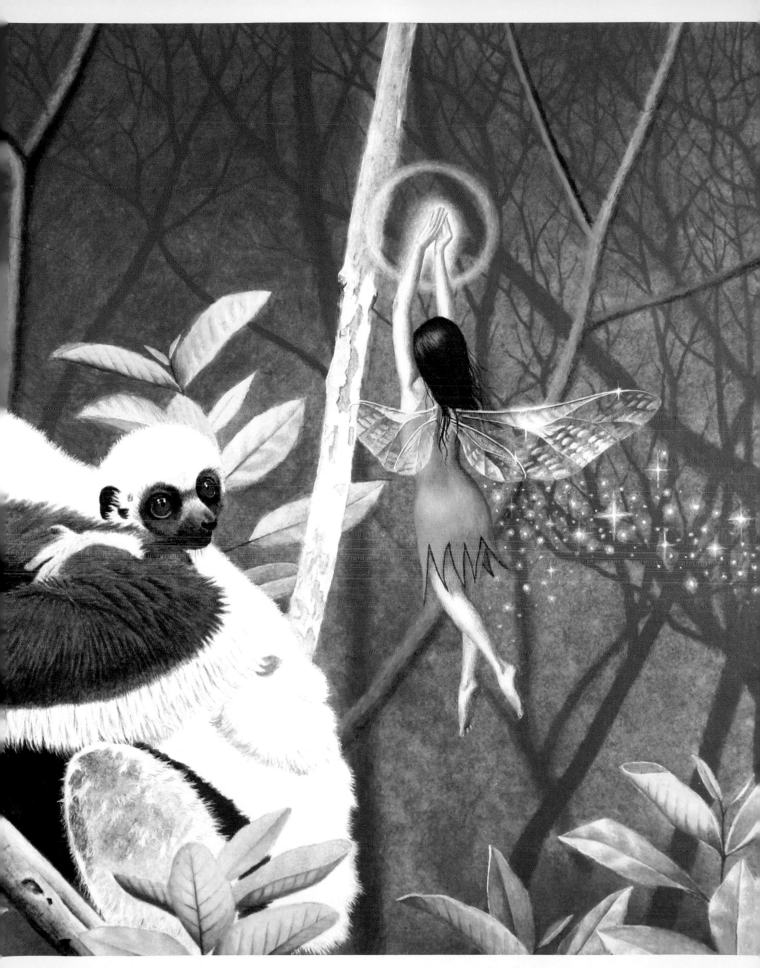

The lemur photo reference used for this painting was provided by
Dr. Glen Apseloff.

Baby's Blessing
Acrylic on illustration board
11" × 14" (28cm × 36cm)

Lily Pad Scene

This little fairy is full of smiles as she watches her tiny sylph fairy friend spring up and dance before her. The little sylph is of good heart and is a friend of fairies.

I chose the blue ground to represent the sky color as a reflection for the water. I painted two shades of this mixture onto the support for the ground. The upper half is lighter than the lower. The two halves are blended in the middle, and the value difference is very slight.

I wanted to create the illusion of a mirrorlike surface on a bright spring day, so the reflections of the lily pads should be clear and dark.

MATERIALS

Surface
Illustration board, toned with white gesso, Cobalt Blue and Ultramarine Blue

Brushes
nos. 2, 3, 6, 8, 12 rounds
nos. 18/0, 12/0, 0, 1 liners
no. 1 detail

Pigments
Burnt Umber, Cadmium Red Light, Chromium Oxide Green, Cobalt Blue, Emerald Green, Payne's Gray, Raw Umber, Titanium White, Ultramarine Blue, Vivid Lime Green, Yellow Oxide

Other Supplies
pencil, white gesso

1 Draw the Composition and Apply the Underpainting
Paint the support with a toned ground of Cobalt Blue and Ultramarine Blue mixed with white gesso. Next, draw the design, then create a full-value underpainting with thinned (diluted) Payne's Gray. I rarely use Payne's Gray for an underpainting, but I wanted to keep the color scheme cool.

2 Paint the Lily Pad Undersides and Render the Fairy

Paint the undersides of some of the lily pads with white gesso. Render the outline of the fairy and paint it with white gesso. This provides the foundation for the underpainting. Next draw the details of the fairy's features with a pencil.

3 Paint the Lily Pads

Introduce color with thin glazes of Chromium Oxide Green. One to three layers is necessary. Add glazes of Emerald Green for the outer edges of the stems, followed by Vivid Lime Green to bring out the realism.

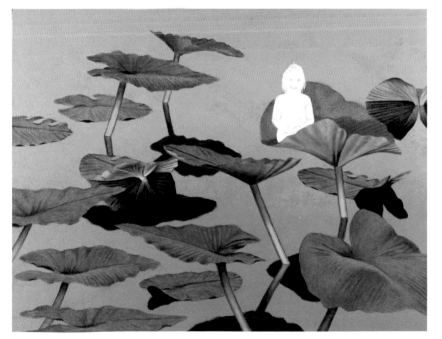

4 Develop the Lily Pads and Reflections

Darken the reflections with a mixture of Ultramarine Blue and Burnt Umber. Apply three to four layers to achieve the correct value structure.

Thinly glaze the undersides of a few lily pads and reflections with Chromium Oxide Green and then with thin layers of Yellow Oxide. Add a touch of Vivid Lime Green as well.

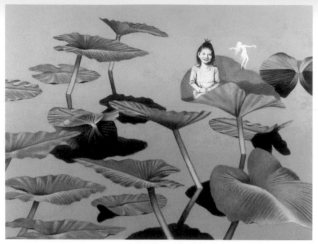

5 Finish Painting the Lily Pads

For increased realism, paint some of the sky's local color on the lily pads. Glaze the parts with one to four layers of Ultramarine Blue mixed with white gesso to complete this illusion. Apply very thin glazes to create a smooth fade-in into the highest value for the highlights.

6 Underpaint the Large Fairy and Render the Small Fairy

Underpaint the larger fairy with Raw Umber. Then, outline the tiny fairy and paint it with white gesso to prepare it for painting.

Detail: Painting the Eyes

When depicting fairies interacting with each other or looking at something, it's important that their eyes are painted correctly. In this painting, the young fairy is obviously looking at her friend. I painted her pupils on the right side of each eye first. Then, I painted the irises. As you can see, there's more sclera showing on the left side. With the pupils placed in the correct position, the viewer can easily see where the fairy is looking.

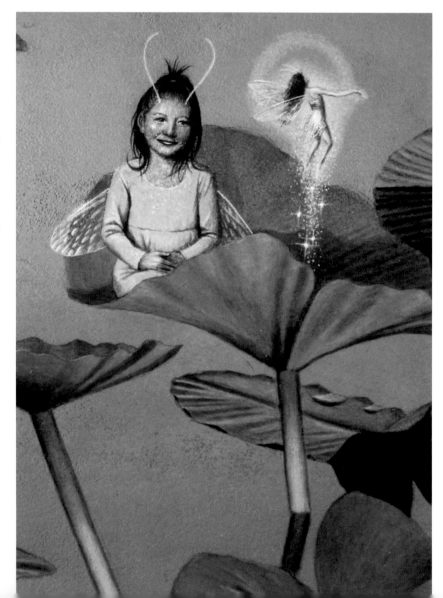

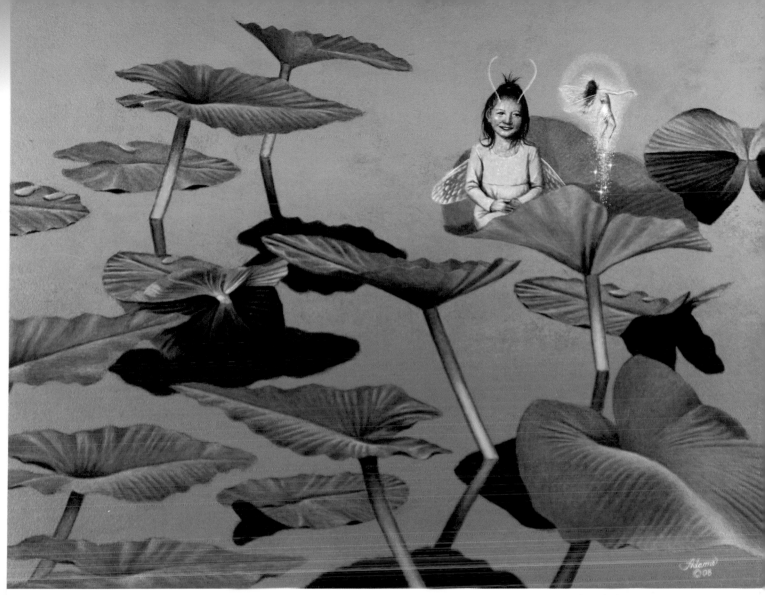

7 Finish Painting Both Fairies

Glaze the larger fairy with layers of Cadmium Red Light to develop the flesh tone. Glaze the fairy's dress with Chromium Oxide Green followed by Vivid Lime Green, then touch it up with Emerald Green over the dark values. Outline the wings with white gesso, then glaze them with Emerald Green and add highlights with Titanium White.

Underpaint the tiny fairy with Raw Umber, then add a halo with white gesso. Lightly scumble white gesso below the fairy to create a sense of upward movement. Add sparkles, lightly glazed with Yellow Oxide. Develop her skin tone with thin glazes of Chromium Oxide Green and Vivid Lime Green. Paint the hair with Burnt Umber.

Sparkle Enhancement

Most sparkles are accompanied by points of light, which enhance the effect of illumination. Simply stipple the area with white gesso or Titanium White.

103

4 Develop the Trees and Ground

Glaze Chromium Oxide Green over the tree branches, rocks, tree trunks, debris and moss. Then apply glazes of Yellow Oxide, Vivid Lime Green, Cadmium Yellow Medium and Cadmium Yellow Light over portions of the ground.

Cover the fairy's arms with masking tape. Then, use an old, frayed no. 10 bristle brush to lightly dab the foreground rock and tree trunk with Payne's Gray. Using the same brush, apply Chromium Oxide Green, Yellow Oxide, Vivid Lime Green, Cadmium Yellow Medium and Cadmium Yellow Light in the same manner. Finally, to create more realism, use the same colors and a no. 1 detail brush to stipple the tree and rock. Remove the tape.

5 Finish the Landscape and Underpaint the Fairies

Glaze Burnt Sienna over some areas of the ground, then bring the bright light of the sky down into the landscape with glazes of white gesso. Add more highlights to the rocks and debris of the landscape to marry the sky with the land.

Carefully glaze the fairy with Raw Umber for the underpainting. You need to apply one to five layers to achieve the proper contrast.

Draw the sylph (tiny fairy), then paint her with the same toned gesso used for priming the support.

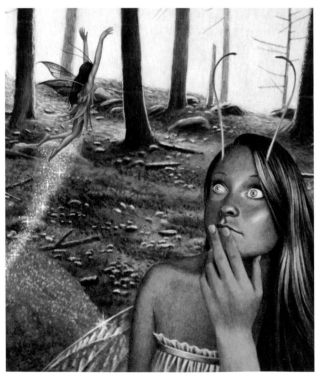

Detail
This fairy is looking directly at the tiny sylph. Simply position the irises in the correct spots to create a convincing gaze.

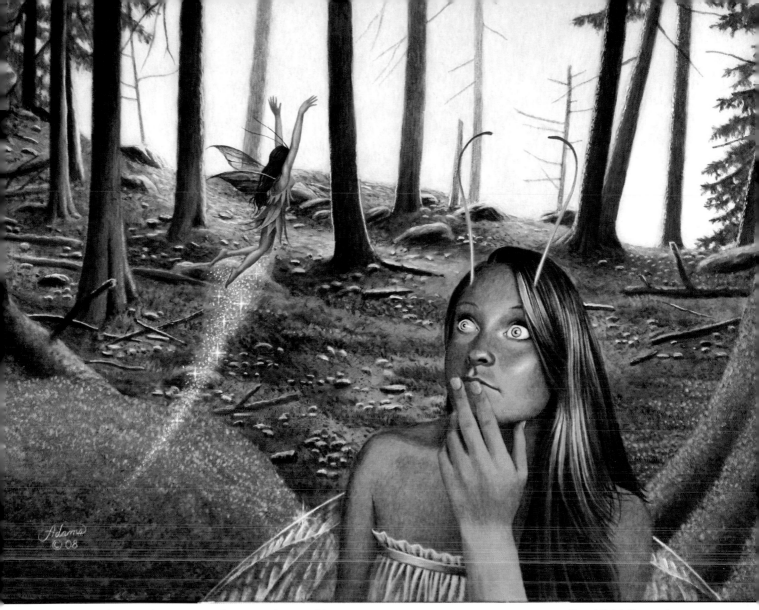

6 Complete Both Fairies and Create the Sparkles

Glaze the dark values of the fairy's hair and eyelashes with Ultramarine Blue. Glaze the medium and lighter values with Burnt Umber and Cadmium Red Light, then add highlights with touches of white gesso.

To develop the fairy's skin tone, apply glazes of Cadmium Red Light. Glaze her eyes with white gesso, then Ultramarine Blue. Glaze the antennae with Emerald Green and Vivid Lime Green.

Underpaint the small fairy with Raw Umber, then apply glazes with Chromium Oxide Green. Darken her hair with several layers of Ultramarine Blue. Paint the lighter tone of her skin with Vivid Lime Green.

Create the sparkles below the tiny fairy with a scumble of white gesso, then stipple with a detailing brush. Apply a thin glaze of Yellow Oxide and dot with white gesso.

Forest Sylph Encounter
Acrylic on illustration board
8½" × 11" (22cm × 28cm)
Collection of Chris McBride

demonstration

Autumn Scene

Fairies love to use magic. They especially love using their wands. The three fairies on the right are illuminating the lichen on the rocks, preparing for the coronation of the new queen. Two onlookers (the child fairy in the tree and the fairy on the ground below her) watch their magic at work. The child fairy is eager to learn the art of lighting objects, so she watches with a keen eye.

1 Prime the Support and Draw the Design

Prime the illustration board with a mixture of white gesso and Burnt Umber. Then, render the design onto the support with a pencil. Keep it light; just a suggestion of the outline of objects is sufficient.

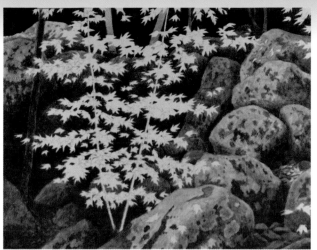

2 Create the Underpainting

Develop a full-value underpainting with several layers of Raw Umber and Ultramarine Blue applied separately. Glaze Raw Umber over all the rocks first (establishing their structure), then add two to four layers of Ultramarine Blue. This completes the value structure of the rocks; the detailing comes next.

3 Begin Painting the Rocks and Ground

Use a toothbrush to spatter Payne's Gray on the rocks. This simple technique adds more realism to the objects.

Use the toned gesso from step 1 to paint the debris of leaves on the ground. This adds to the feeling of the autumn season.

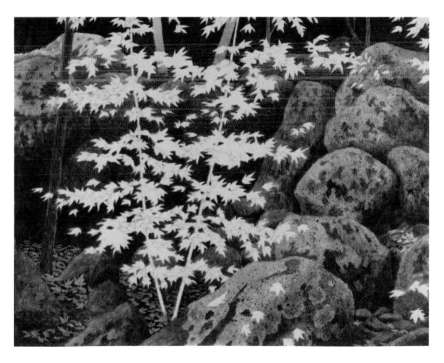

4 Develop the Rocks

Glaze Ultramarine Blue over the rocks, then add Payne's Gray over the dark areas of the lichen and rocks. Create the lichen with dabs and dashes of white gesso.

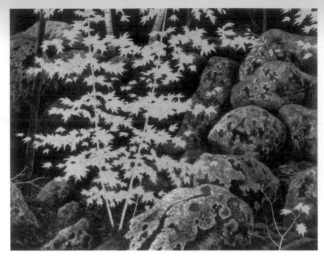

5 Develop the Lichen, Leaves and Debris

Light up the lichen by stippling more white gesso. Then, add a light glaze of Ultramarine Blue. Glaze some leaves and debris with Cadmium Yellow Medium, Cadmium Yellow Light, Yellow Oxide and Cadmium Red Medium. This is glazing, so, apply the color separately.

Add a bit of Chromium Oxide Green to the mossy area at the top of the rocks on the left. Add some extra detail such as limbs and branches, with the toned gesso used to prime the support in step 1.

6 Paint the Tree Trunks and Leaves

Glaze Burnt Umber over the tree trunks and limbs, then add a glaze of Ultramarine Blue. Paint the tree leaves with glazes of Yellow Oxide.

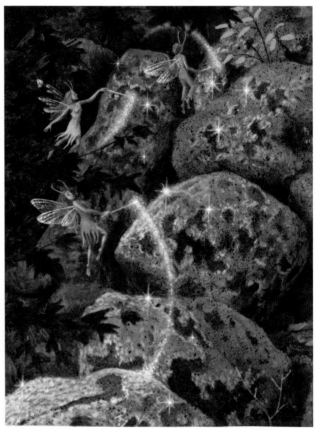

7 Develop the Tree Leaves and Begin the Fairies

Glaze the leaves of the trees with Cadmium Red Medium, then add glazes of Acra Violet to deepen the value of some of the leaves. Next, glaze Dioxazine Purple over some of the leaves to push them back into the picture.

Outline the fairies, then apply a layer of the toned gesso that was used for the primer of the support in step 1. Create the underpainting of all the fairies with Raw Umber.

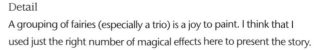

Detail

A grouping of fairies (especially a trio) is a joy to paint. I think that I used just the right number of magical effects here to present the story.

8 Paint the Fairies and Complete the Sparkles

Bring the fairies to life with glazes of Cadmium Red Light for the skin tone, Chromium Oxide Green and Vivid Lime Green for the clothing, and Emerald Green for the wings.

With glazes of white gesso, paint arcs flowing from the tips of the fairies' wands, then spot the arcs with dots of white gesso. Use a no. 0 liner to mark some Xs here and there to represent sparkles. Add a light glaze of Yellow Oxide over the sparkles. Stipple the sparkles with Titanium White to finish.

Lighting the Rocks
Acrylic on illustration board
8½" × 11" (22cm × 28cm)

Garden Scene

I found the contrast of textures in this wagon with potted plants wonderful and eye-catching. The child fairy is a nice addition and completes the theme of this composition.

MATERIALS

Surface
illustration board, toned with white gesso and Raw Umber

Brushes
nos. 3, 4, 6, 8 rounds

nos. 18/0, 12/0, 0, 1 liners

no. 1 detail

Pigments
Acra Violet, Burnt Sienna, Burnt Umber, Cadmium Red Light, Cadmium Red Medium, Cadmium Yellow Light, Cadmium Yellow Medium, Chromium Oxide Green, Dioxazine Purple, Emerald Green, Payne's Gray, Raw Umber, Titanium White, Ultramarine Blue, Vivid Lime Green, Yellow Oxide

Other Supplies
pencil, white gesso

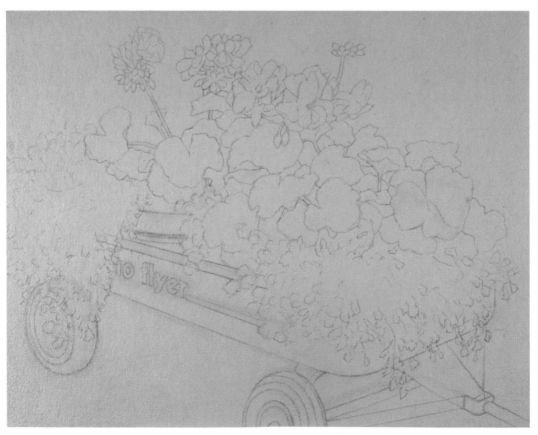

1 Draw the Composition

Prime the support with a mixture of white gesso and Raw Umber. Then, draw the scene with a pencil. Use just enough lines to place the major objects and render the basic outlines.

2 Draw the Fairy and Start the Underpainting

Draw all the masses of the little fairy, including the head, arms and clothing, then fill in the rest of the details such as the facial features. Underpaint the background and foreground surrounding the wagon with Raw Umber. Apply one to three layers as necessary.

3 Develop the Darker Areas

Glaze the background and the dark values of the foreground with Ultramarine Blue and Payne's Gray. The combination of brown and blue looks black, but it creates a richer effect than would be achieved by painting the area with black paint. Paint the foreground with Burnt Umber, then dot the ground with Yellow Oxide. Apply a glaze of Burnt Sienna over the foreground.

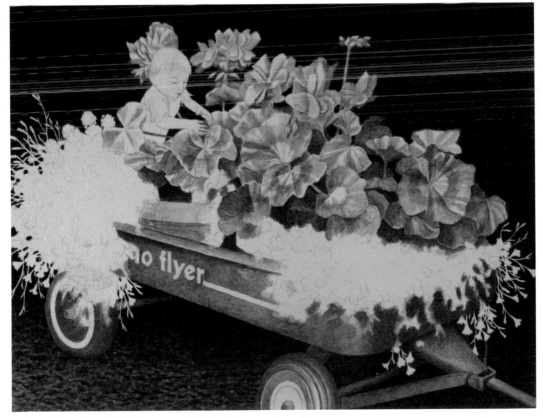

4 Underpaint the Flowers and Wagon

Create a full-value underpainting of the begonias and wagon with Raw Umber. Next, paint in some of the flowers with the toned gesso from step 1.

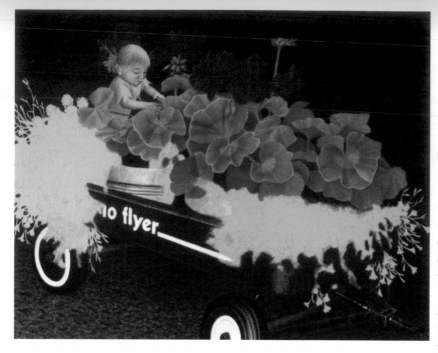

5 Paint the Begonias and Wagon

Glaze the begonias with Chromium Oxide Green, then enhance the leaves with Vivid Lime Green. Strengthen the dark values with Ultramarine Blue. Paint the dark areas of the blossoms with a mixture of Cadmium Red Medium and Ultramarine Blue, then glaze the flowers with two layers of Cadmium Red Medium.

Glaze the wagon with Cadmium Red Medium, then thinly glaze with Ultra marine Blue. Darken some of the values near the back and front of the wagon with glazes of Payne's Gray. Glaze Acra Violet over the red to bring out the richness of the color. Paint the text with white gesso.

Work out the details of the wagon's attachments with Ultramarine Blue, Payne's Gray and Burnt Sienna. Apply the blue first to establish the chipping paint, followed by two to three coats of Payne's Gray. Then, apply Burnt Sienna for the rusty areas. Add the highlights with white gesso.

Underpaint the young fairy by glazing with Raw Umber.

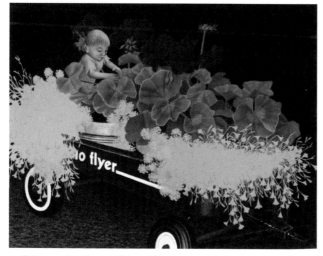

6 Start the Rest of the Flowers With a Gesso Layer

Paint the foundation for the rest of the flowers with the same toned gesso from step 1. The gesso will help you fill in the missing details around the perimeter of the design and in the areas of overlapping.

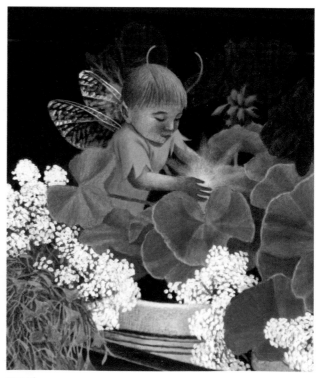

Detail
Painting flowers realistically can be quite challenging. Each flower is composed of different shapes, giving each variety a unique look. Examine the flowers' leaves as well. Leaf shapes are specific to each flower.

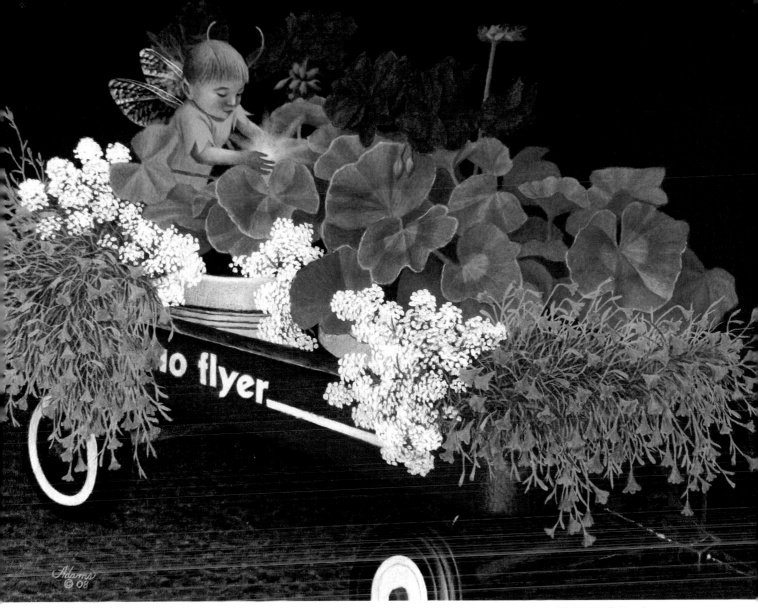

7 Paint the Alyssums and Bell Flowers

Paint the alyssums with Titanium White. Lightly glaze the dark areas with Ultramarine Blue. Glaze the bell flowers with Acra Violet and Dioxazine Purple.

Paint the little fairy last. Glaze the fairy's arms and face with layers of Cadmium Red Light. Apply three to four thin layers over the hands, as this is where the ball of light will be painted. Paint the clothing with glazes of Chromium Oxide Green over the dark values, then glaze Vivid Lime Green over the entire garment, overlapping the Chromium Oxide Green. Using white gesso for the ball of light, paint around the fairy's hand and between the fingers. Glaze outward with very thin applications. Apply several layers of the white gesso around the hand until it appears very white. Then, glaze over the light with diluted Yellow Oxide.

Finally, paint in the wings with white gesso, then glaze over them with Emerald Green. Spot the wings with undiluted Titanium White to give them a shiny look.

A Little Magic Touch
Acrylic on illustration board
8½" × 11" (22cm × 28cm)

115

Rainbow Scene

The fairy in this painting is embracing her staff. A fairy staff is not an ordinary walking stick! It's a magical tool of light that amplifies the power of the fairy. Not just any fairy can own such a staff. They are presented to the most honorable fairies whose intentions are to shower nature with love and light.

MATERIALS

Surface
Masonite, primed with white gesso

Brushes
nos. 4, 6, 8, 10 rounds
nos. 12/0, 0, 1 liners
no. 1 detail
large, frayed bristle brush

Pigments
Acra Violet, Brilliant Blue, Burnt Sienna, Burnt Umber, Cadmium Red Light, Cadmium Red Medium, Cadmium Yellow Light, Cadmium Yellow Medium, Chromium Oxide Green, Dioxazine Purple, Emerald Green, Payne's Gray, Raw Umber, Ultramarine Blue, Vivid Lime Green, Yellow Oxide

Other Supplies
masking tape, pencil, sea sponge, white gesso

1 Draw the Design

Prime the Masonite with white gesso. Briefly outline all the objects with a pencil to establish the design. Then, carefully tape over the fairy with masking tape. Tape is better when a large area needs to be protected. Use short strips of tape and work your way around the fairy until she's completely covered.

2 Underpaint the Rocks

Underpaint the rocky background with Raw Umber. Apply one to four layers as necessary. Then remove the masking tape from the fairy.

3 Start the Rocks and Waterfall

Glaze Payne's Gray over the rocks. Then, glaze Ultramarine Blue on the rocks and the falling water.

4 Paint the Moss-Covered Rocks

Use a sea sponge to spot the rocks with Chromium Oxide Green, then apply Emerald Green, Vivid Lime Green and Cadmium Yellow Medium in the same manner. Finally, use a no.1 detail brush to stipple the moss with dots and dashes of Cadmium Yellow Light.

5 Develop the Waterfall

Touch up the main waterfall with thin glazes of Ultramarine Blue over the outer edges to give it a more pronounced misty look. Then, glaze areas where the water is pouring over the rocks with white gesso. This gives the waterfall a more realistic appearance.

Glaze an arc of white gesso across the waterfall to prepare the space for the rainbow.

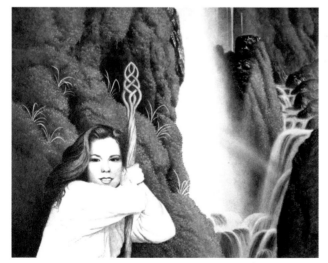

6 Paint the Rainbow and Start the Fairy and Grass

Paint the rainbow with very thin glazes of Acra Violet, Cadmium Yellow Light, Emerald Green and Brilliant Blue (see page 96 for more on painting rainbows). The rainbow is faint here because the mist from the waterfall is light.

Underpaint the fairy and her staff with Raw Umber. Add more grassy details to the background.

Detail
I didn't apply any paint at all to a large portion of the larger waterfall. I just left the white primed surface untouched.

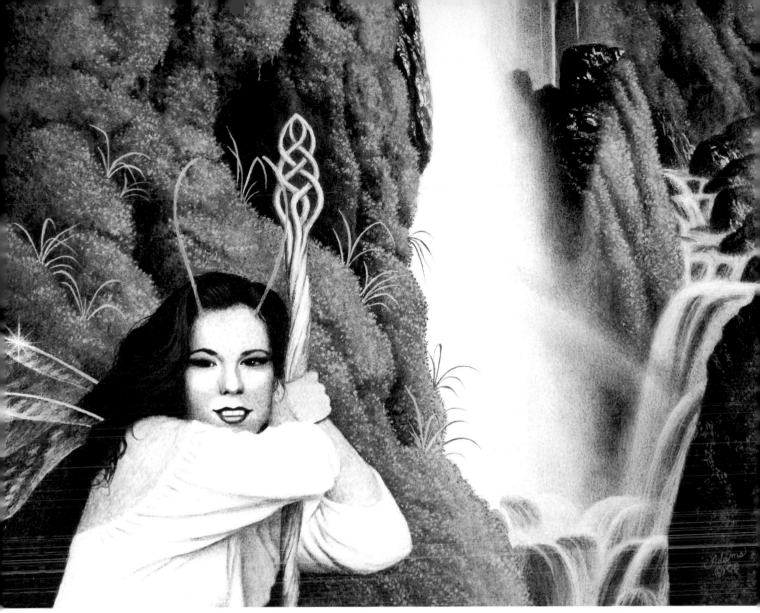

7 Finish the Grass and the Fairy

Glaze the grass with Vivid Lime Green and Chromium Oxide Green.

Layer the fairy's hair with two to three glazes of Ultramarine Blue. Next, apply glazes of Burnt Umber and add highlights with Yellow Oxide.

Very lightly glaze the fairy's skin color with Cadmium Red Light. Use Ultramarine Blue to darken her eyes and apply Dioxazine Purple for her eyelids. Paint her blouse with Ultramarine Blue.

Journey's End
Acrylic on Masonite
11" x 14" (28cm x 36cm)

Gallery

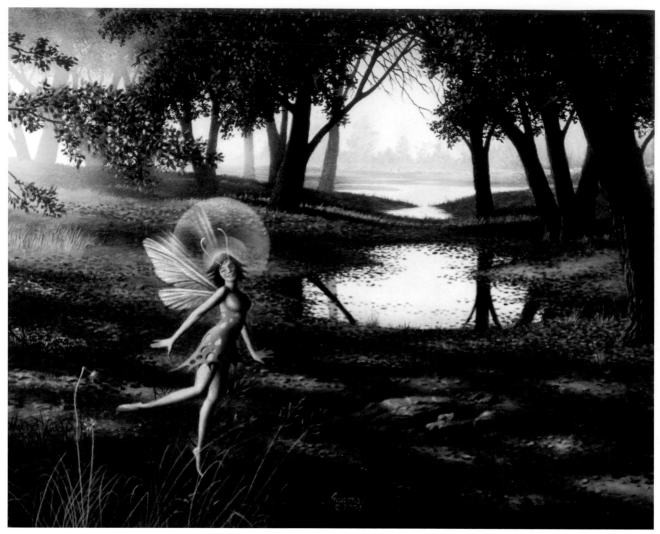

Autumn Magic
Acrylic on illustration board
8" × 10" (20cm × 25cm)

A Fall Scene
This happy-go-lucky fairy is enjoying the autumn weather. There are four more tiny fairies in the background trees.

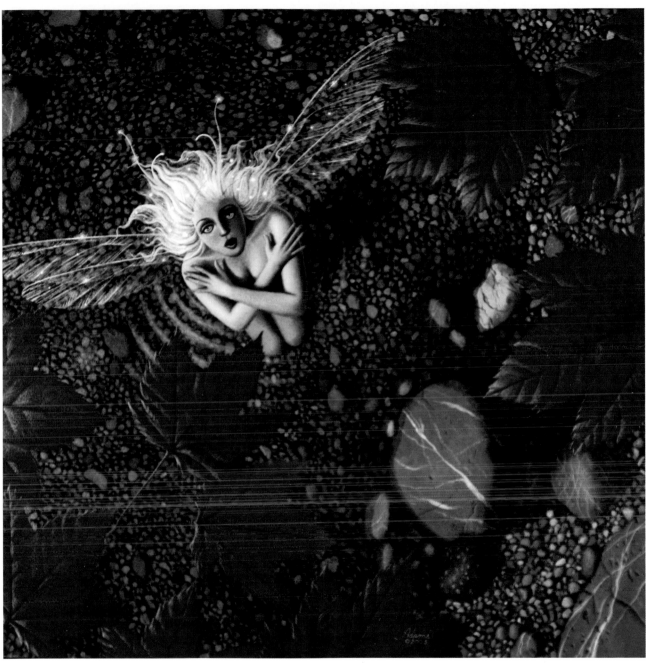

Oh!
Acrylic on Masonite
12" × 12" (30cm × 30cm)

Aerial View
This fairy was bathing in the water, when she was suddenly startled. If you look closely at the leaves, you'll notice that I painted small ants there.

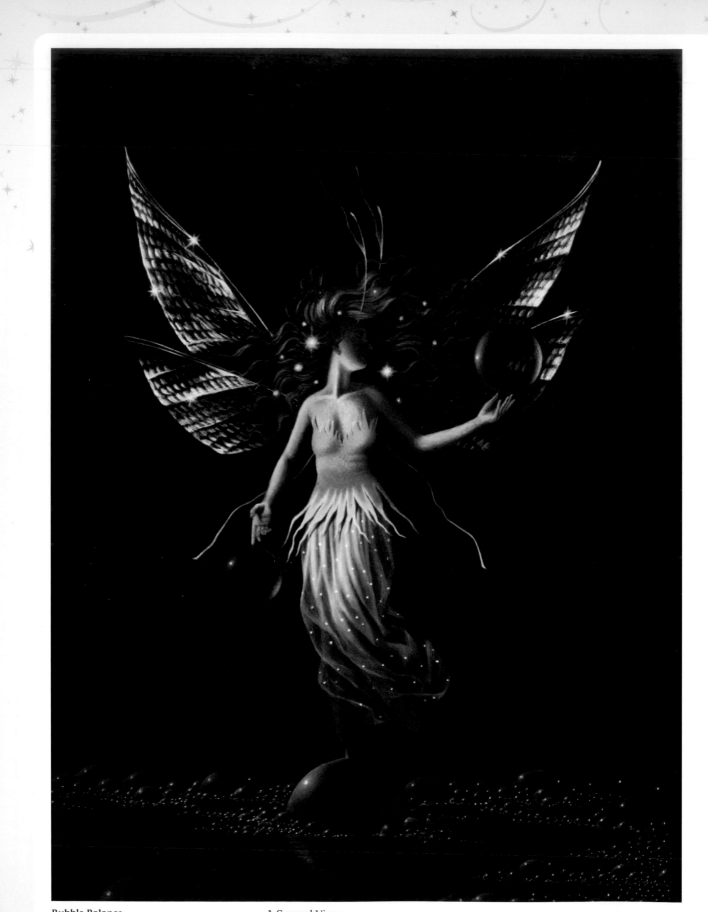

Bubble Balance
Acrylic on illustration board
12" × 9" (30cm × 23cm)

A Surreal View

Here is a surreal look into the fairy realm.

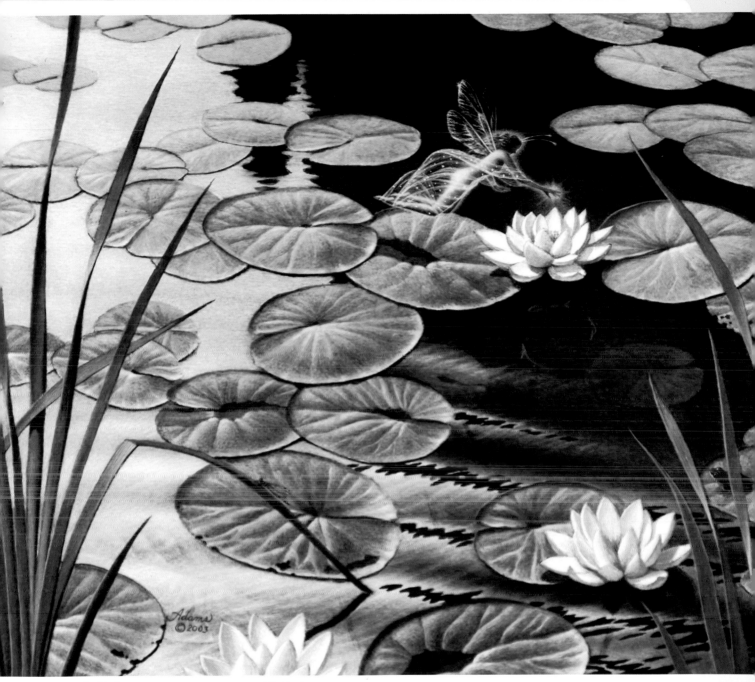

Water Lily Magic
Acrylic on illustration board
8" × 10" (20cm × 25cm)

Lily Pads

This fairy flies from lily to lily as she does her magic. Hidden in this piece are a damselfly, a frog and three fish.

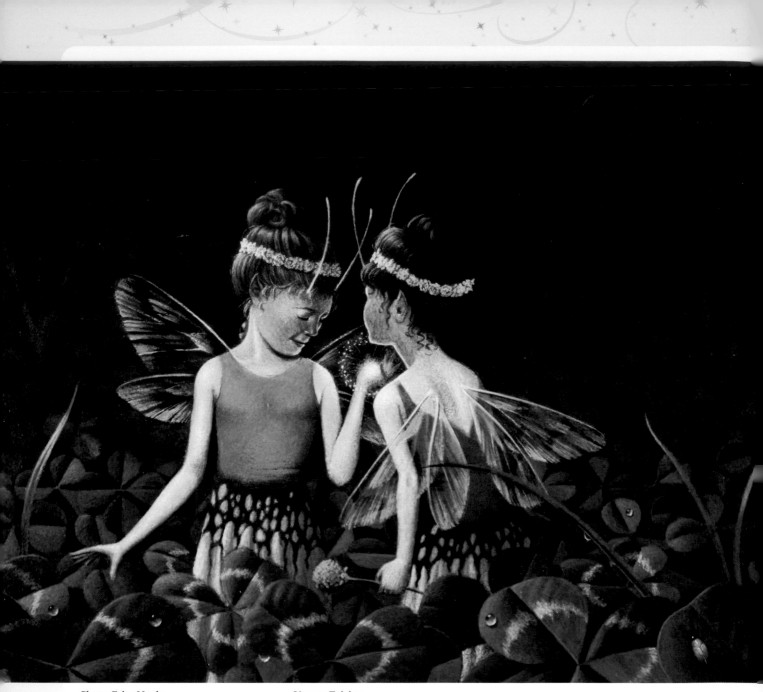

Clover Fairy Magic
Acrylic on Masonite
6" × 8" (15cm × 20cm)

Young Fairies
These little fairies enjoy playing in their clover patch.

Conclusion

Being an artist has been my life for quite some time. I cannot think of a better profession for me. I love the work, and I enjoy sharing it with others. Throughout my career, I've seen many smiles, and even tears, when people view my artwork. It's a good feeling to see my art touch someone emotionally. I believe my artwork has a place in this world to uplift, inspire and give people a brief time for pause—a relaxing moment of escape from their daily activities.

The key to being a good artist is observation. Look at this world with the eyes of an artist. Take mental notes of everything you see. Carry a sketchbook or camera with you everywhere you go to capture what interests you. Make note of the play of light upon objects and sketch or photograph it. Present your work for critique by fellow artists and friends. It's important to know what others think about your work. I've learned much through feedback from other people.

Don't be too concerned about any mistakes you make in a painting. It's through our mistakes that we become better artists. I've made thousands of mistakes, but it never detoured me from my desire to become a better painter. I keep my passion close to my heart and press on. You should do the same.

Don't concern yourself too much about style, and don't push it. There are no set rules on how to paint. Each artist has his own way of making a picture. Follow your intuition and your passion, and do the best you can. Be the best that you can be, and before you know it, your style will emerge.

I wish you the best. Happy painting!

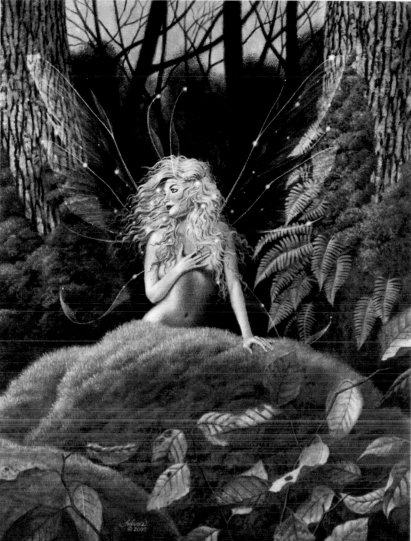

A Fair View
This fairy is pleased with what she sees in this woodland scene.

Woodland Fairy
Acrylic on hardboard
14" × 11" (36cm × 28cm)
Collection of Renae Preston

Index

If you're going to paint— paint with IMPACT!

DragonArt Fantasy Characters Kit
by Jessica Peffer
ISBN-13: 978-1-60061-316-6
ISBN-10: 1-60061-316-0
Kit, 32 page booklet + art materials,
#Z2923

Fans of fantasy will find everything
you need—instructional booklet,
pencils, paper, markers and more—to
start drawing a whole host of amaz-
ing fantasy characters including elves,
dwarves, orcs and more. Easy to follow
instructions take characters from
basic sketches to shaded and colored
finished illustrations.

**Dreamscapes: Creating Magical Angel,
Faery & Mermaid Worlds**
by Stephanie Pui-Mun Law
ISBN-13: 978-1-58180-964-0
ISBN-10: 1-58180-964-6
paperback, 176 pages, #Z0688

Dreamscapes is a unique guide to
painting beautiful watercolor angels,
faeries and mermaids in their own
worlds (celestial, woodland, garden
and seascapes) step by step. Fantasy
artist Stephanie Pui-Mun Law walks
you through her process, showing and
describing her techniques for creating
fantasy scenes full of wonder and mys-
tery. You will begin by learning about
essential materials, including brushes,
paints and paper, then move on to
important techniques such as planning
and sketching; figure proportions;
specific characteristics of angels, faeries
and mermaids (including clothing);
developing backgrounds; and finishing
techniques that add an air of magic.

**Enchanting Fairies: How to Paint
Charming Fairies and Flowers**
by Barbara Lanza
ISBN-13: 978-1-58180-956-5
ISBN-10: 1-58180-956-5
paperback, 128 pages, #Z0667

Fantasy artists and decorative paint-
ers alike will love the charming fairies
presented in this book. Start off by
learning how to draw children, adoles-
cents and adults, then add elements
such as wings and pointy ears to create
fairies with sweetness and mischief.
Demonstrations feature individual fair-
ies and groups, from simple subjects
without backgrounds to those with
background elements. The demonstra-
tions allow you to paint exactly as the
author has done or they can be used
as a starting point for original artwork.
From playing in a sun-drenched field
of wildflowers to hiding by a shady
woodland stream, or dancing amidst
snowflakes, you can capture the
essence of fairies with the tips and
techniques provided in this book.

These books and other fine IMPACT titles are available at your local fine
art retailer or bookstore or from online suppliers. Also visit our website at
www.impact-books.com.